Imaginative Still Life

Moira Huntly

VAN NOSTRAND REINHOLD COMPANY
NEW YORK CINCINNATI TORONTO LONDON MELBOURNE

Copyright © 1983 by A & C Black (Publishers) Ltd
Library of Congress Catalog Card Number 82-21969
ISBN 0-442-23849-5

Printed in Hong Kong

Published by Van Nostrand Reinhold Company Inc.
135 West 50th Street
New York, New York 10020

Fleet Publishers
1410 Birchmount Road
Scarborough, Ontario M1P 2E7 Canada

16 15 14 13 12 11 10 9 8 7 6 5 4 3 2 1

Huntly, Moira.
 Imaginative Still Life.

 Bibliography: p.
 Includes index.
 1. Still-life in art. 2. Art—Technique. I. Title.
N8251.S3H86 1983 751.4 82-21969
ISBN 0-442-23849-5

Contents

Illustrations

Sketches, diagrams and drawings by the author throughout the book

Conté pencil: *Violins*

Introduction

Still life painting brings to the artist the same excitement and pleasure as, say, landscape painting and need not be treated merely as an exercise in composition and perspective for the beginner. It consists of more than the ubiquitous bowls of fruit and vases of flowers (satisfactory as those subjects are to paint) for there is a wealth of subject matter and materials to choose from, for those who use their eyes and imagination.

It is an interesting thought for the beginner that the still life painter shares many of the problems faced by the landscape painter. (A demonstration is given on pages 21–5.) Arranging a group of objects to form an interesting composition in the studio is like creating a personal landscape but without the distraction of wind, changing light and weather. Concentration on the problems of drawing, composition and the mixing and selection of colour thus comes more easily.

For the experienced painter, still life painting can further personal vision and stimulate the search for unity in his work. Great artists have been influenced by the disciplines of still life composition and a study of some famous examples (which are illustrated in this book) shows the wide variety of approach, from the traditional painting of Treck in the seventeenth century and Courbet in the nineteenth, to the abstract treatment by Picasso and Braque, who started the Cubist movement in the early twentieth. With the advent of Cubism, still life played a more important part in the painting of an era. This pointed to the vast potential for still life painting. Whichever medium the artist chooses becomes his means of expressing ideas, but it is original ideas, together with composition, that create the importance of a painting. Many artists specialise in a particular medium but it is often stimulating to try other methods and materials. Sometimes the subject itself suggests the medium employed, because the artist wants to achieve certain effects only possible with that medium.

Today there is a wide range of material readily available and plenty of opportunity to experiment. This book has chapters on different media and the materials required for each, so the reader can open it at any chapter without having to seek some of the information elsewhere.

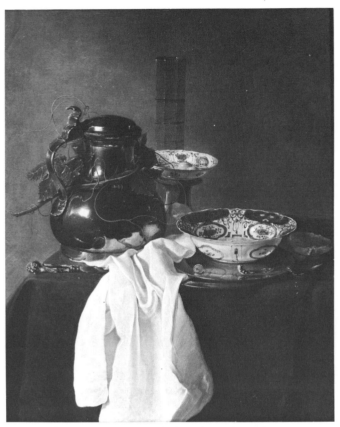

J.J. Treck: *Pewter, China and Glass* Reproduced by courtesy of the Trustees, The National Gallery, London

It can be rewarding, and enjoyable, to look at still life paintings by great artists. Most of the objects chosen are everyday things, but the style of painting has been changing over the centuries.

Dramatic lighting is a feature of the seventeenth-century Italian paintings of Caravaggio, whereas the Dutch paintings of Vermeer are of softly lit interiors – and even the figures have a static quality that makes them appear an integral part of a still life.

Dutch painters of the seventeenth century were interested in closely observed detail and must have spent many hours on their highly finished paintings of glass, pewter, china and, especially, flowers. *Pewter, China and Glass* by J.J. Treck is a fine example of just such a highly finished style of painting.

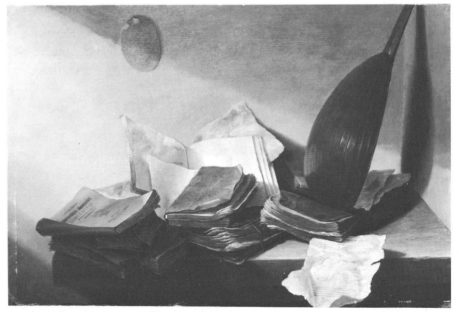

Jan Davidsz de Heem: *Still Life with Books* Reproduced by courtesy of the Rijksmuseum-Stichting, Amsterdam

Jan Davidsz de Heem, in his *Still Life with Books*, gives a beautiful portrayal of subtle lighting that is intensified as it falls on the white paper, and softened where the shadow falls on the wall behind. Three centuries later, the same kind of objects – sheets of music and musical instruments – also inspired Picasso, whose conception and medium were often quite different.

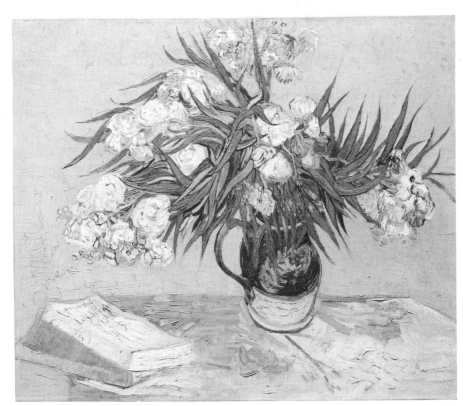

Vincent Van Gogh: *Oleanders* Reproduced by courtesy of The Metropolitan Museum of Art, Gift of Mr and Mrs John L. Loeb, 1962

Unlike earlier Dutch work, Van Gogh's still life paintings are full of life. When he paints blossom it looks freshly picked and his paintings of potatoes, old boots and sunflowers have brush strokes full of movement. The painting of *Oleanders and Books* has such a strong pattern of movement. The spiky leaves point in different directions and even the shadows on the table add to the feeling of movement. The flowers are not defined precisely, as in the early Dutch flower paintings, and yet they are clearly flowers — one is expecting a petal to drop off at any moment.

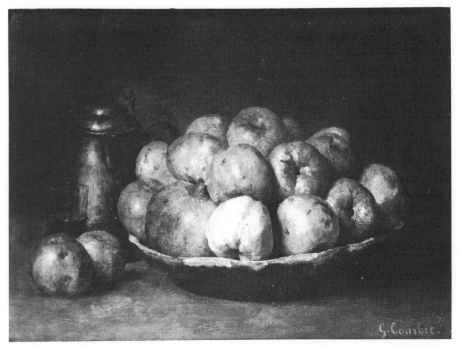

Gustave Courbet: *Still Life, Apples and Pomegranate* Reproduced by courtesy of the Trustees, The National Gallery, London

Chardin, the great French painter of still life in the early eighteenth century, chose humble objects which he often painted in a limited range of low tones. Courbet in the nineteenth century painted his *Apples and Pomegranate* with similar richness and simplicity.

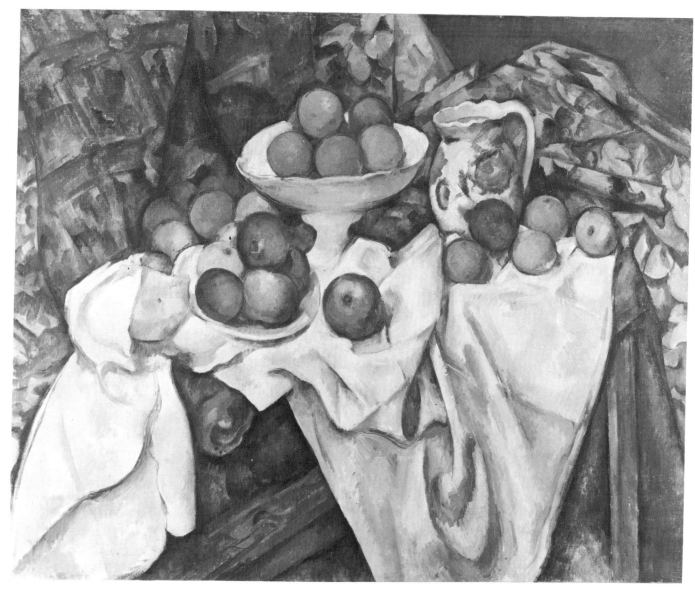

Paul Cézanne: *Still Life with Fruit and Pitcher* Reproduced by courtesy of the Musées Nationaux – Paris

The nineteenth and twentieth centuries provide a wealth of examples of still life painting. Cézanne may be singled out because he was an important innovator and a link between the nineteenth- and twentieth-century art movements. He has often been referred to as the father of Cubism. He explored still life for its planes, forms, shapes and abstract qualities, and the Cubists continued this exploration of pattern, shape, colour and texture to make a visual impact based on simple objects.

Cézanne's painting, *Fruit and Pitcher*, clearly shows the underlying abstract qualities. There is strong pattern and movement throughout the painting. The folds in the cloth lead the eye up to the fruit and pitcher, the placing of the fruit becomes a pattern on the light cloth; at the same time, Cézanne keeps the painting of the objects and the folds simplified. Cézanne was able to give life to the inanimate objects that he painted.

The Cubist movement itself was started by Picasso and Braque when they met in 1907, and it was to generate many other ideas and movements. Cubist paintings of still life proliferated. Instead of portraying a group of objects from the usual single vantage point, they

were painted as if from more than one vantage point at once – so objects might be shown from the front, the side and above within the same painting. The convention of painting what was seen of a group of objects from only one particular eye level was shattered.

Braque, like Cézanne, was a master of still life painting; it formed a major part of his work. His colour schemes were often subtle and the brush-work free; but the powerful construction is clearly seen. The objects in Braque's painting, *Guitar, Fruit and Pitcher*, are similar to those that inspired both Cézanne and Picasso. In Braque's interpretation, the colours are muted and there is an exciting combination of curved and angular shapes. The flat cut out shapes and strong design clearly show the influence of collage, which Braque had previously used extensively.

The artist who has had the greatest influence on the art of our time is Picasso. Still life has been a recurring theme for him. His early painting, *Fruit Dish, Bottle and Guitar*, was painted in 1914. The objects are broken down into a series of flat planes; they no longer have volume, their shapes making a flat pattern. Much of the colour is monochromatic, relieved by a few areas of bright flat colour, and texture is used to create different planes. Picasso continuously developed many styles and techniques – one of his later paintings is reproduced on page 152.

The few great still life paintings reproduced here show a great diversity in painting and they speak to us in different ways about common themes.

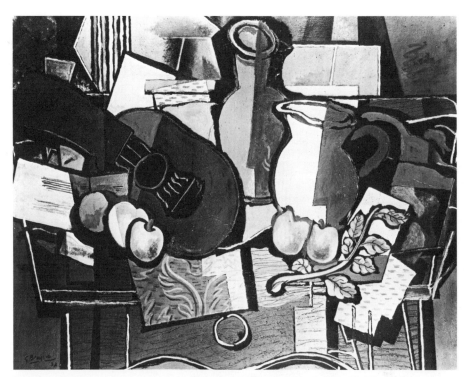

Georges Braque: *Guitar, Fruit and Pitcher* Collection Mr & Mrs M. Lincoln Schuster, New York © ADAGP Paris 1982

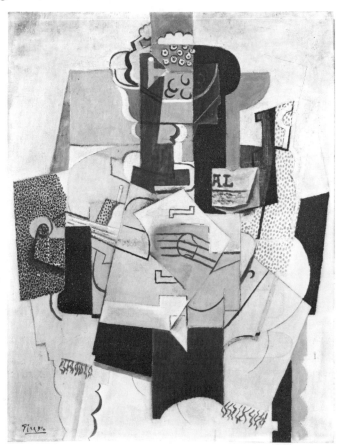

Pablo Picasso: *Fruit Dish, Bottle and Guitar* Reproduced by courtesy of the Trustees, The National Gallery, London

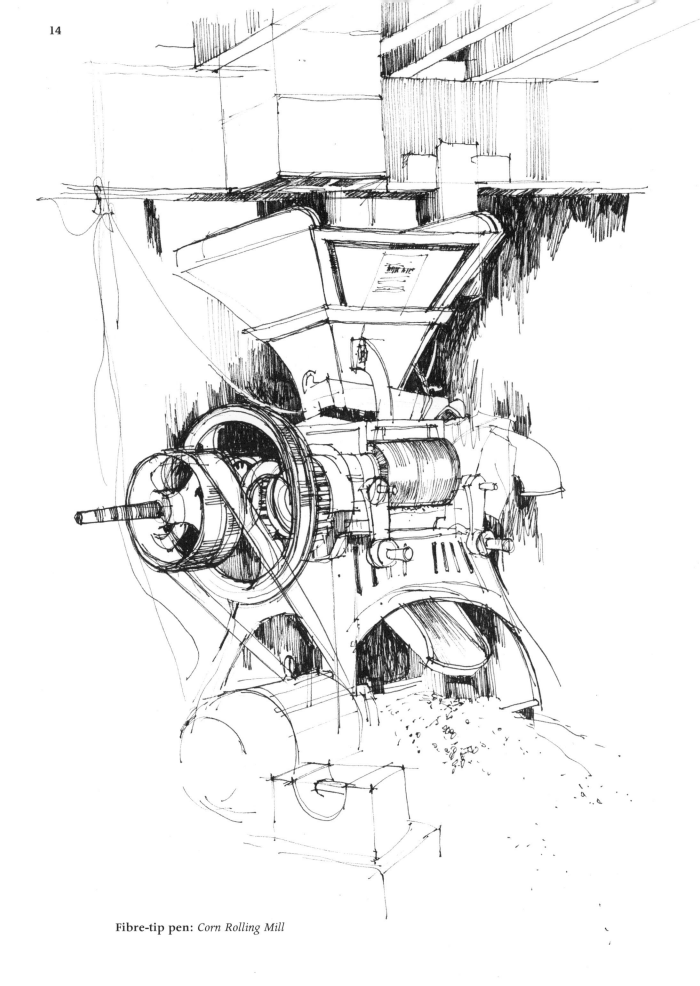

Fibre-tip pen: *Corn Rolling Mill*

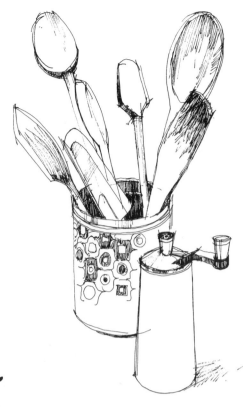

Ideas for Still Life Painting

In this chapter I suggest some subjects to paint, ranging from everyday objects about the home to *objets trouvés*. These are objects that are found or come across, perhaps on a walk. I discuss the value of still life painting and its relevance to landscape painting and demonstrate the similarities, and I suggest some still life subjects that can be seen within the landscape.

My drawing of the corn mill opposite is an example of an object found by chance. Whilst looking for a landscape subject I noticed machinery in the corner of a barn and the shapes immediately interested me. The drawing was made with a fibre tip pen and could form the basis of an idea for a painting in the studio at a later date.

Everyday objects

There is an enormous variety of everyday objects that form good material for still life painting and are easy to find. In addition to the usual choice – the ornaments, vases of flowers and bowls of fruit – there are plenty of objects in the kitchen. Look well at the shapes of jars, pots, fruit and vegetables, and cooking implements. Musical instruments have interesting shapes which have often been used in still life groups, and so too have pot plants with their variety of leaf shape. How about looking in the shoe cupboard, the greenhouse or the garden shed for paintable objects?

Still life painting allows the artist a great deal of freedom in the arrangement or structure of a painting as well as in the choice of object painted and the colour used. The actual business of choosing and arranging objects is absorbing and enjoyable, and this is where the creative process begins. Just as you select part of a landscape to paint, so you select a group of objects. The initial construction of the group is of paramount importance to the painting. Select objects that interest you, for it is difficult to make a good painting out of something that does not really inspire you – although an experienced painter will be able to find inspiration in almost anything.

Conté pencil: *Shoes*

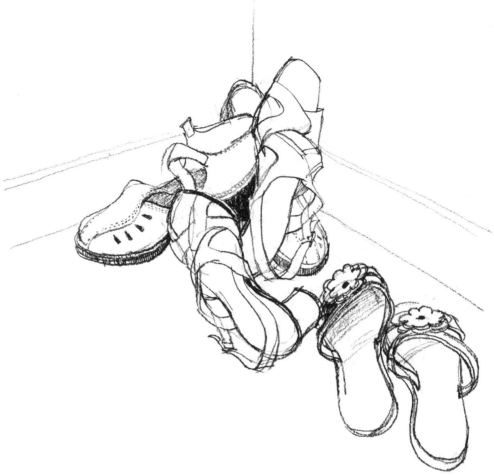

Unarranged objects

In addition to arranging a group of objects and creating the composition yourself, you may come across an interesting 'accidental' composition of objects which you can paint *in situ*, or on the spot. Perhaps clothing flung carelessly over the back of a chair in the bedroom or hanging up on a peg on the door. Quite often it is the 'accidental' or unarranged group of objects that is the most inspiring to draw, such as shoes dropped carelessly on the floor in the corner of the room.

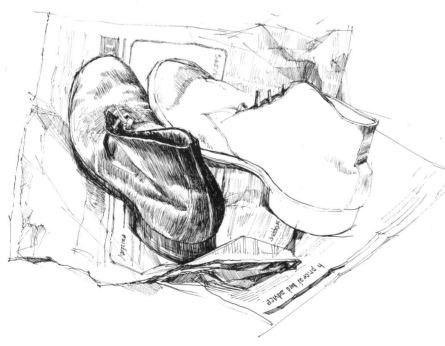

Pen and ink: *Shoes on Newspaper*

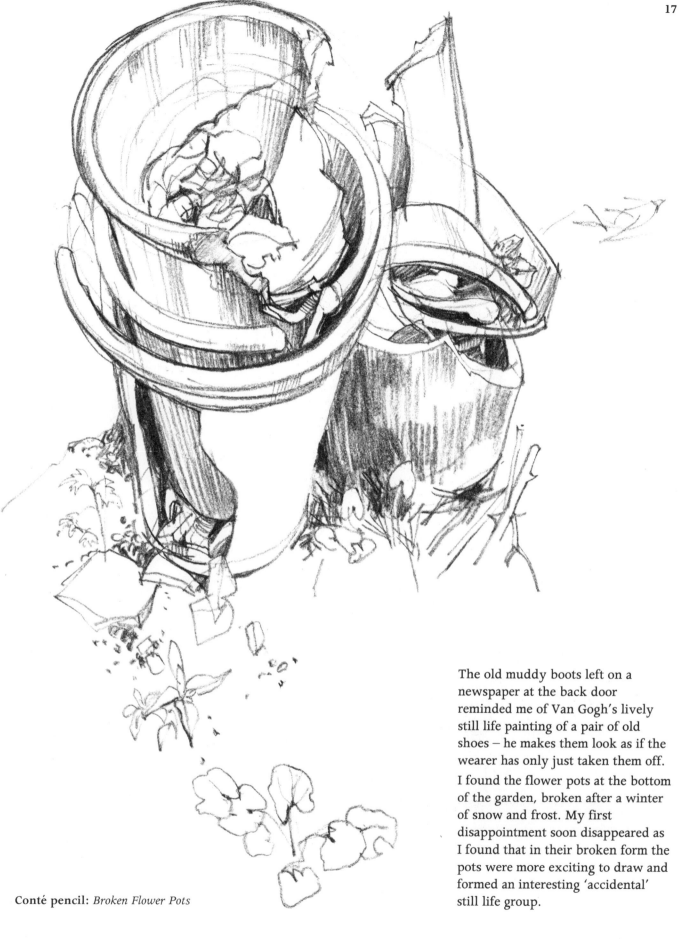

Conté pencil: *Broken Flower Pots*

The old muddy boots left on a newspaper at the back door reminded me of Van Gogh's lively still life painting of a pair of old shoes – he makes them look as if the wearer has only just taken them off.

I found the flower pots at the bottom of the garden, broken after a winter of snow and frost. My first disappointment soon disappeared as I found that in their broken form the pots were more exciting to draw and formed an interesting 'accidental' still life group.

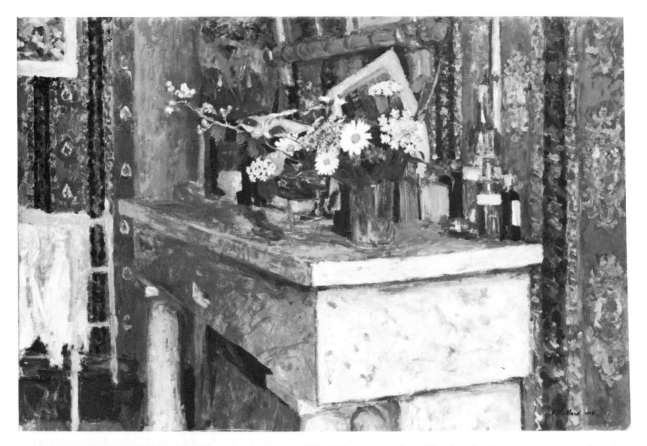

Edouard Vuillard: *The Chimneypiece* Reproduced by courtesy of the Trustees, The National Gallery, London

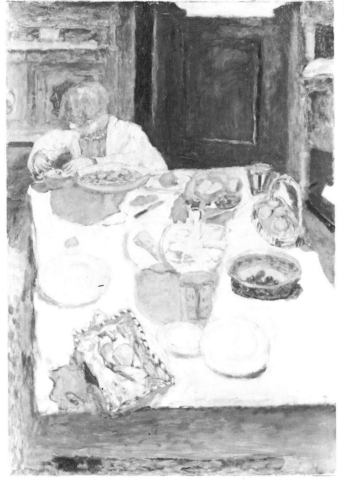

Pierre Bonnard: *The Table* Reproduced by courtesy of The Tate Gallery, London © ADAGP Paris 1982

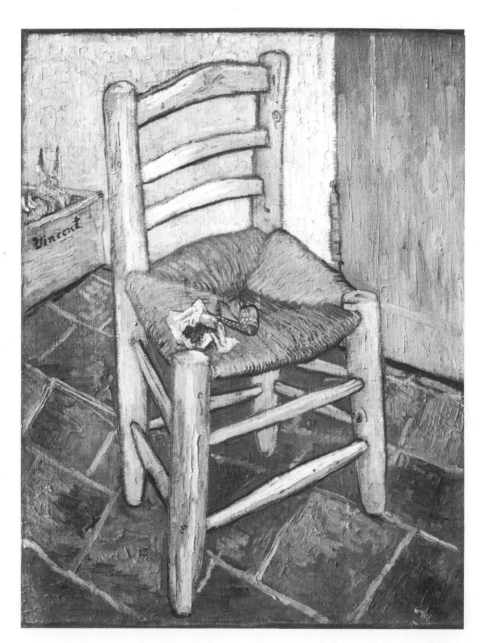

It is noticeable that none of the great still life paintings has a falsely 'arranged' background of drapery. Whether the objects are arranged or not, they are usually painted to look in their natural setting, *in situ*. For example, in *The Chair and the Pipe* by Van Gogh, the chair stands in the corner of the room, a simple wall and door as a background, the pipe and tobacco look as if they have just been left there for a moment. Who would have thought that an old yellow chair could make such a first-rate subject? In fact, it has become one of Van Gogh's best known paintings.

One of Bonnard's favourite still life subjects was the dining table, often covered with a chequered cloth. His painting, *The Table*, reproduced here, has a simplified subdued background and the table is strongly lit from above. Bonnard often painted objects on a table, capturing a moment of fleeting light that illuminated the whole surface.

The painting opposite of *The Chimney Piece* by Vuillard is another masterpiece, a deceptively simple painting of the objects on the mantelpiece and the garments airing on the clothes-horse. The arrangement on the canvas is such that I want to go on and on looking at it, the composition and colour being so totally satisfying.

Objects with an affinity

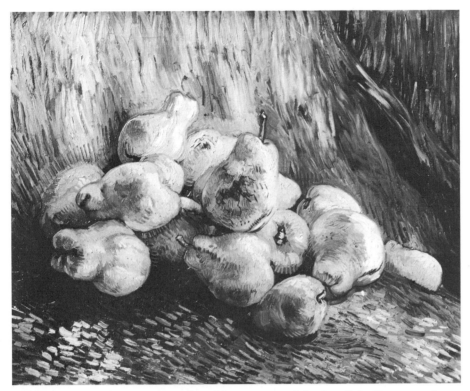

Vincent Van Gogh: *Pears* Reproduced by courtesy of the Staatliche Kunstsammlungen Dresden, Gemäldegalerie Neue Meister

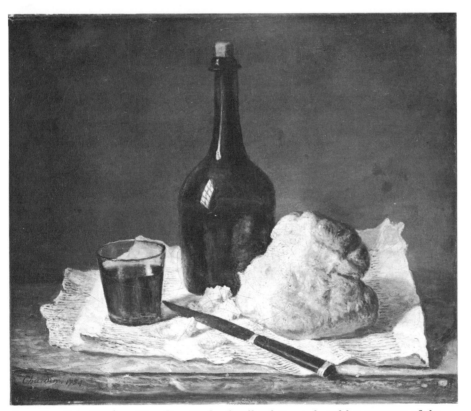

Jean Baptiste Siméon Chardin: *Study of Still Life* Reproduced by courtesy of the Trustees, The National Gallery, London

Just as different parts of a landscape relate to each other, so objects for a still life painting should relate to each other. For instance, fruit and a fruit bowl, jugs and dishes on a cloth, bread and wine, music and musical instruments, fish and lemons, shells and seaweed. I am sure that you can think of many more. The background is an equally important part of the painting and should also have an affinity with the objects.

In the painting of pears by Van Gogh the background is of nothing, but the affinity lies in the brush strokes, the way in which the background painting goes with the way the fruit is painted. The pears would look wrong on, for example, a smoothly-painted piece of satin or velvet.

Chardin's *Study of Still Life*, painted in the eighteenth century, is a classic example of a painting where objects have an affinity: bread and wine on the table, against a dimly lit interior.

Simple objects can make a good painting, common household items become works of art when arranged and painted by masters of still life painting. Many of the objects that inspired them can be found in the home today. The group of objects in the Chardin painting could be arranged in a similar way and you could paint your own interpretation of the subject.

Still life as a prelude to landscape painting

Whatever your own preferred style of painting, the same problems occur with still life painting as with any other subject. Problems of colour, tone, composition, personal interpretation (choosing what to emphasise and what to subdue), all have to be considered. This means that the experience gained by painting still life is a good preparation for other kinds of subject and, in my opinion, almost an essential step in practice for landscape painting.

A painter has to decide where to place things on the canvas. This is called composition, and applies equally to still life and landscape. Will the subject fit better if I use the canvas vertically or horizontally? How much of the landscape should I include or how many objects should I choose for the arrangement? I find that a simple composition works best. Then I have to judge proportions by making comparisons between the different heights and widths of objects: this applies whether they are, for instance, jugs and bottles, or trees and buildings.

First I look for the lightest-coloured area in the subject and then the darkest-coloured area. These set the scale for my two extremes of tone value. All the other colours that I mix fall in between; by constantly referring to the two extremes I can decide more easily how light or dark to mix each area of colour. It is often difficult to judge how light or dark a colour is, so I have to keep making these comparisons. For the mixing of paint, it is usually easier to experiment in the studio.

In a landscape I make a note of the tone value at the horizon and judge whether the sky is lighter or darker than the land or whether they blend. In a still life group I look at the tone value where the vertical background meets the base – perhaps they merge together in shadow, as in Courbet's painting of the apples and pomegranate on page 11.

It all sounds difficult and it is, but everything becomes easier with practice. There is no easy way when it comes to painting, but there lies the challenge and the excitement of having conquered some of the difficulties.

Parallels between landscape painting and still life painting

The first step-by-step demonstration compares landscape and still life painting. It also illustrates a logical way of painting, especially for the beginner. This is by no means the only way of painting, and is only one of the methods described in this book, all of which are suggestions for the development of your own ideas.

I call this method my 'back to front' way of painting. I draw the subject on the canvas and then paint the background. Next I paint the objects in the middle distance, superimposing their painted edges over the background paint. Then, last of all, I paint the foreground.

I find that if the background is painted last there is a tendency for a beginner to paint the brush strokes round the objects, leaving a gap. In that case the painting does not achieve the illusion of one thing being behind another.

DEMONSTRATION IN OILS

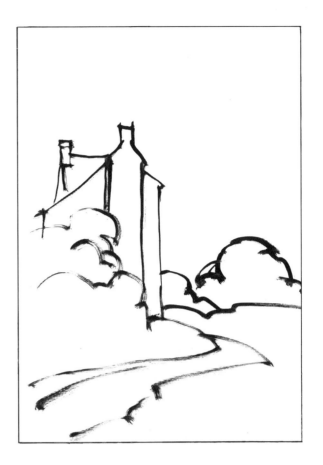

Landscape: STAGE 1

For the landscape painting I have chosen a tall house with two chimneys so that I can echo the shapes of the two bottles in the still life painting. The tallest chimney is placed to the left of centre (which I find more interesting than if I placed it in the centre) and makes a better balance with the short shape of the trees.

The composition is drawn in freely with a small oil brush and burnt umber thinned with white spirit. At this stage there are no details – just a simple outline.

Landscape: STAGE 2

Still using thinned paint, I add a little Winsor blue to the burnt umber, which makes a rather pleasant 'greeny' brown. Using varying strengths of this mixture, I paint in the darks with a larger brush.

The sky is the 'backcloth' so I paint it next. This time the paint is thick, with no white spirit, and I use titanium white and add to it a very small amount of Winsor blue and burnt umber. The brush strokes are put on the canvas in a vigorous way and I make no attempt to go carefully round the outlines; in fact I deliberately paint into the outline.

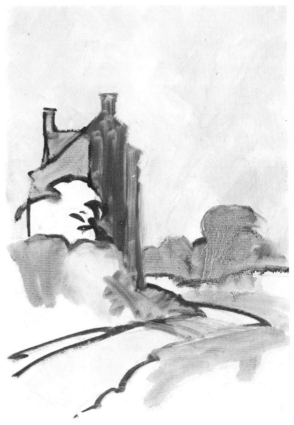

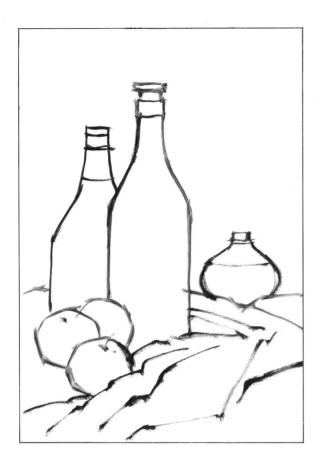

Still life: STAGE 1

Just as the landscape is drawn in freely with a brush, so I draw the outlines of the objects, placing the tallest bottle to the left of centre and balancing it with the short wide shape of the pot. I also like to look at the shape of the background between the objects. This background corresponds to the 'backcloth' of the landscape painting.

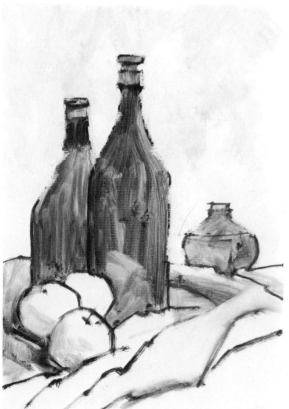

Still life: STAGE 2

I establish the dark tones in the group with fairly thin paint, thinning the paint still further with more white spirit for the lightest tones. Then the light blue grey wall behind the group (the 'backcloth') is painted. I use thick paint straight from the tube, painting well into the outlines of the bottles and pot.

Landscape: STAGE 3

At this stage the distant trees are painted with varying soft tones of grey green. Then I paint the walls, roof and chimneys, making the brush strokes overlap the sky slightly, for this makes the house appear to be in front of the sky. Some of the sky colour is introduced into the painting of the road, as this helps to give a unity to the painting by echoing a colour already used. A touch of lemon yellow on the distant field and on the bushes in front of the house adds interest to the rather subtle colour scheme.

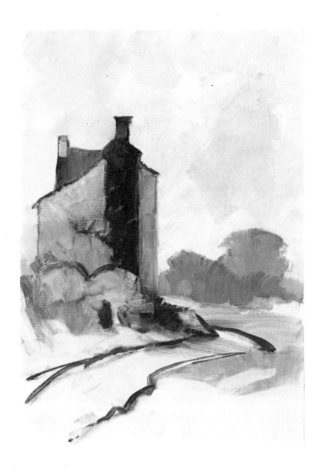

Landscape: STAGE 4

I complete the painting of the chimneys and the house and turn my attention once more to the distant trees. These need a little more definition but without too much detail. The little trees and bushes in front of the house, however, are more detailed because they are closer to me. Finally, I complete the foreground, superimposing some of the grasses over the painting of the road.

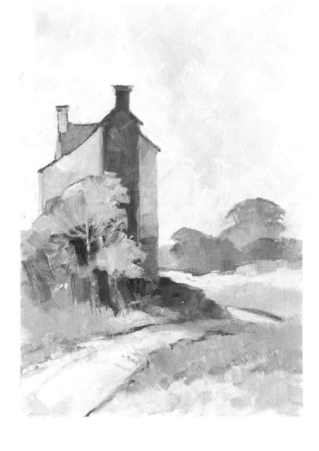

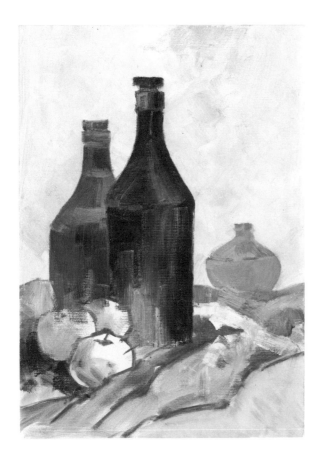

Still life: STAGE 3

I colour the foreground with a thin wash of burnt umber to lose the harsh white of the canvas. Then with thick paint, I mix mid-tones of green grey for the pot and cloth. The bottles are painted next, with the brush strokes superimposed on the painting of the background.

The edges of the dark paint of the bottle are now physically on top of the background, so helping to create a three-dimensional illusion.

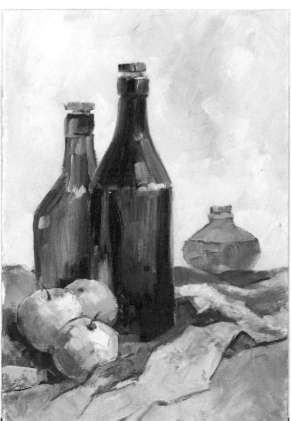

Still life: STAGE 4

Notice in Stage 3 that the dark brush strokes on the bottles break into the apple shapes. Now I paint the light apples with brush strokes overlapping the dark bottles. This procedure again helps to give a three-dimensional effect. Foreground details are then completed and highlights painted on the bottles.

Obviously you will not always find a landscape so closely resembling a still life group. The object of this demonstration is to show how the basic themes or shapes recognised in a landscape also occur in still life.

If you look at a still life group, such as a bottle and apples, in terms of curves and shapes, their relationship to each other and the way their edges overlap, then you will come to realise the greater range of possibilities for painting indoors.

Objets trouvés (found objects)

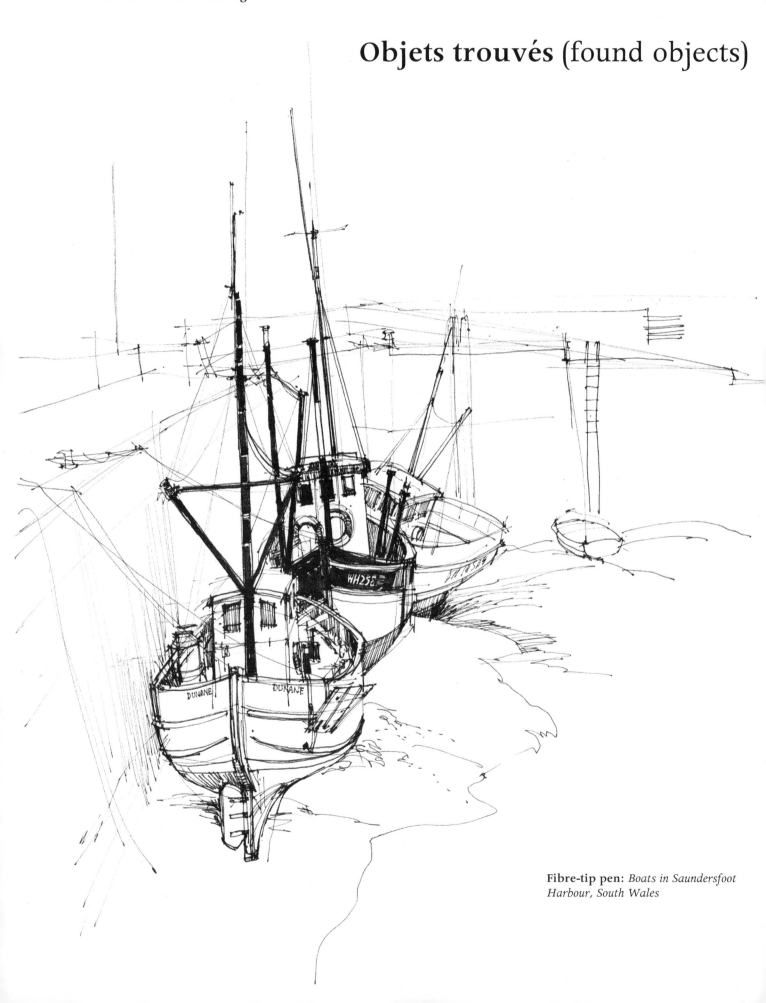

Fibre-tip pen: *Boats in Saundersfoot Harbour, South Wales*

Landscape, rural or urban, has plenty of still life subjects to offer. I like to keep my eyes open when I am walking in the countryside or along the seashore, and I always take interesting collections of stones, shells, animal skulls and driftwood back to the studio, in fact anything at all that has an interesting form or colour. On other occasions I make studies in builders' yards, boatyards or farmyards and find all kinds of objects such as the corn mill shown on page 14.

Carry a sketch book with you whenever possible so that you can make quick notes to be used later, for a drawing or painting to be executed in the studio. The time you spend on a drawing is not important; a quick sketch and a few notes can give plenty of information for a later painting.

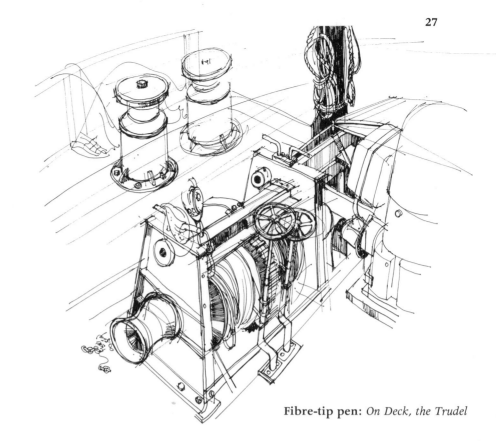

Fibre-tip pen: *On Deck, the Trudel*

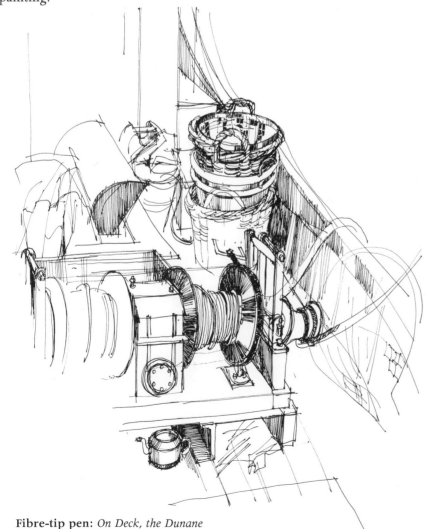

One morning I spent only two hours in a harbour and made enough sketches to form the basis for several paintings. Boats make excellent still life subjects, especially when the tide is out and they lie still. Looking round the harbour I found all kinds of objects with interesting shapes: anchors, fishing baskets and nets. The decks of the fishing boats were covered with equipment that was also fascinating, though intricate, to draw, but I like drawing machinery and find it visually exciting.

Some people groan at the idea of painting still life because they associate it with rather tedious exercises in drawing dull objects as often conducted by schools in the past. But it is obvious from the famous paintings reproduced in this book that still life painting is very varied, stimulating and rewarding.

Fibre-tip pen: *On Deck, the Dunane*

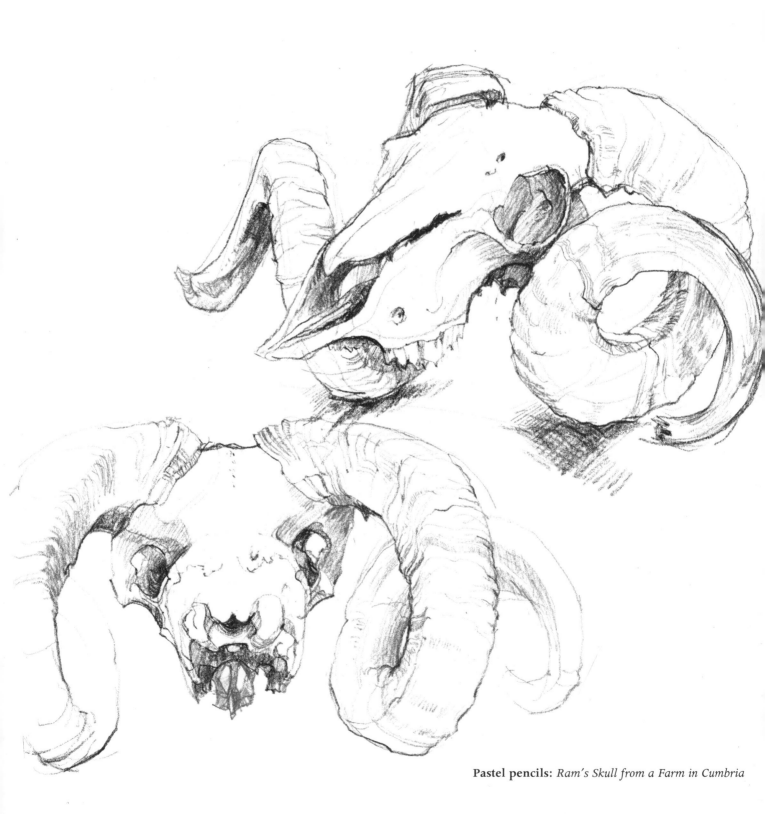

Pastel pencils: *Ram's Skull from a Farm in Cumbria*

Ammonite

Sea Urchin

CHAPTER TWO

Drawing

As children our natural instinct is to draw, or make marks on paper, without worrying about the results – and it is a happy, carefree activity. As adults we often lose our confidence in drawing freely because we want a more sophisticated result.

I believe that anyone who genuinely wants to draw or paint is halfway to doing so, but it is the second half that is difficult – the training of the hand to produce what is in the mind's eye. Drawing is basically interpreting what you see in a linear way, and I believe it to be a necessary step towards painting. Learning to 'see' and know a subject comes through the process of drawing. Rules of perspective can be followed and techniques acquired, and competent drawings can be achieved, but a good drawing is more than a competent copy of something. A great drawing gives life to the subject and is an individual interpretation.

Obviously some people have greater powers of observation, dexterity and imagination than others, but it is a question of practice as well as of motivation. For example, you would not expect to play a piano well unless you practised every day. In fact the more drawing and painting experience that I gain, the more I realise how much there is still to learn – and this excites me. It means that the challenge will always be there.

Drawing the ram's skull (opposite) was a challenge. The skull itself was intricate and the way in which the curves of the horns subtly change direction was difficult to draw. There was only one skull but I found it so interesting that I drew it several times from different angles. Some of the shapes seem quite abstract and I think that the drawings could well form the basis for an abstract still life painting.

Materials

The best equipment will not of itself make you a better artist, for a masterpiece can be drawn with a stump of pencil on a scrap of paper. But good equipment is encouraging and pleasing to use, so buy the best you can afford and do not be afraid to use it freely.

Pencils vary from soft to hard. For most purposes a soft pencil is best.

Charcoal (which is very soft) is excellent for large bold sketches but not for fine detail. It will be easily smudged or rubbed off, but a spray fixative will preserve your drawing. Charcoal pencils are also useful.

Conté crayons, wood cased or solid stick, are available in various degrees of hardness and in three colours: black, red and white. The solid sticks can be used on their side for large areas of tone. Conté is harder than charcoal but will also be smudged easily.

Conté pastel pencils are like ordinary pencils to look at but the centre is of pastel colour which has been treated so that it is strong enough to be sharpened to a point. These pastel pencils are produced in a range of colours and allow drawing in colour, with the same velvety texture that is associated with soft pastels. (See Chapter 5)

Pens These can be special artists' dip pens, such as Gillott 303 or 404, which give a varied line according to the angle at which they are held and the pressure exerted. Alternatively, you can cut your own bamboo or quill pen – but remember that such pens have to be dipped more frequently into the ink.

Fibre tip and felt tip pens are very useful for quick sketch notes, but they will fade in time and are not waterproof.

Paper Cartridge paper (Ledger bond) is available in various qualities and is the most commonly used drawing paper. Bristol Board has a good surface for fine pen work. Ingres paper has a soft surface with a texture; it is used mainly for pastel, charcoal and Conté drawings. Ordinary brown wrapping paper can be used for charcoal or pastel pencil drawings.

Sketch books of one or several kinds of paper are available; or you can make up your own by stapling together separate sheets or odds and ends.

Erasers Kneaded or putty erasers are best. They are soft and, if necessary, can be shaped to a point to lift off pencil, charcoal or pastel errors.

Starting to draw

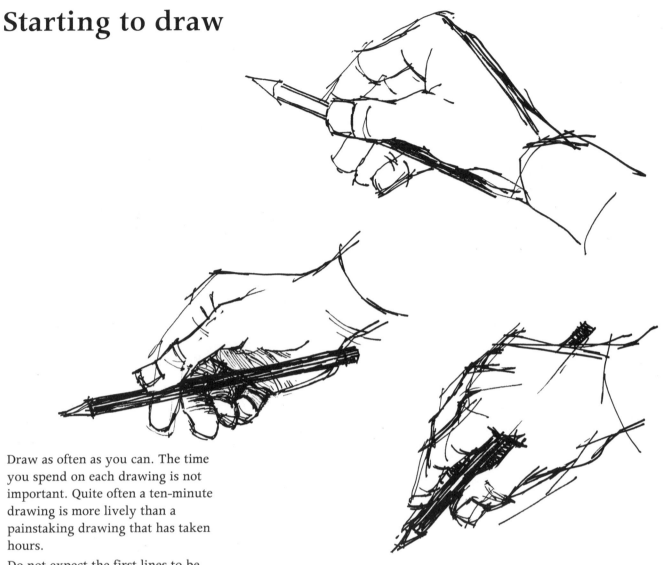

Draw as often as you can. The time you spend on each drawing is not important. Quite often a ten-minute drawing is more lively than a painstaking drawing that has taken hours.

Do not expect the first lines to be right – draw lightly to begin with and do not bother with an eraser. Just make alterations more firmly and the original unwanted lines will gradually disappear as the drawing progresses. It is interesting to see how a drawing has progressed from the first faint construction lines and they usually become an integral part of the finished work. However, be critical. If the drawing looks hopelessly wrong, start again – more than once if necessary – and you learn more about your subject each time.

Drawing is not like writing, so do not grip the pencil tightly. Hold it

lightly and sensitively and be ready
to change the way the pencil is held
according to the directions of the
line. The pencil can be vertical to the
paper or at varying angles.
Sometimes the end of the pencil will
rest in the palm of the hand with the
forefinger on top, sometimes with
the thumb on top.

I rest my little finger on the paper to
steady my hand when I am adding a
fine line or detail – but do resist the
temptation to put in too much detail
too early on in the execution of a
drawing. Breadth of vision, by
which I mean an ability to see the
subject as a whole and not a bit at a
time, is difficult to acquire. Try to
perceive the objects you are drawing
as simple shapes. Nearly all forms
can be simplified into geometric
shapes: two-dimensional (circle,
square or triangle) and three-
dimensional (cone, cube, pyramid,
prism, cylinder or sphere). Mentally
match objects to the appropriate

geometric shapes and then work out
the proportions of these simplified
shapes in relation to each other.

Do not crouch over your drawing;
try to work with your board at an
angle or upright, resting against the
back of a chair or the edge of a table.
Better still, if you have room, use an
easel, for then you can step back and
view both the drawing and the
subject from time to time. If you
draw from the shoulder with the
whole arm there will be more
freedom about your drawing – and
ellipses and straight lines will be
easier to draw.

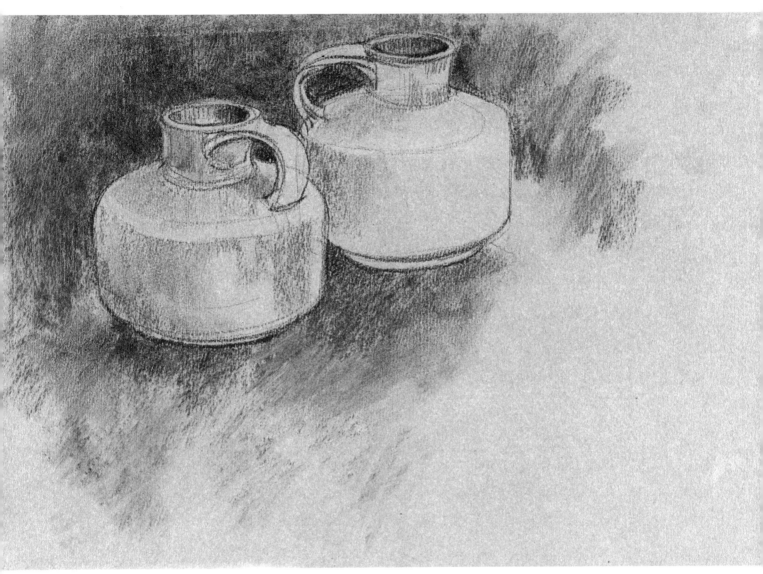

Charcoal on tinted paper: *Pots*

Drawing techniques

In order to make an interesting drawing, you must enjoy it. Sometimes the subject does not seem very interesting but very often the act of drawing creates its own excitement. Ideally, the less you think about *how* you are drawing and the more you think about *what* you are drawing, the better your drawing will be.

However, this kind of confidence is not easy for the beginner. If you want exercises in control, use a scrap of paper and draw the outlines of geometric shapes and try filling each shape with even shading, or draw a series of long controlled straight lines and and then curved lines. Vary the pressure as you draw a line. All these 'doodles' can be practised at odd moments.

Other skills can be acquired if you draw the same group of objects in several different ways. Three-dimensional form or volume can be conveyed by soft shading in charcoal or pastel, by blending with a soft eraser or by finger smudging. Alternatively, volume can be expressed by varying pressure on a single line or by linear shading (the grouping of lines close together, or further apart, to give an impression of tone) with pencil, pen and ink, or fibre tip pen.

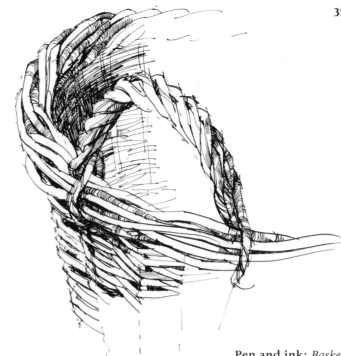

Pen and ink: *Basket*

The apples shown here are an example of linear shading, and were drawn with a fibre tip pen and shadows built up with cross-hatching (the darkest areas having a lot of overlapping lines). The drawing of the basket is also an example of linear shading, this time carried out with a pen and Indian ink and the direction of the lines varied according to the shape of the basket.

The two pots were drawn in outline with a charcoal pencil on Canson Ingres paper and the shading was softly applied with the side of a stick of charcoal, sometimes blended by my finger or a putty eraser.

Pen and ink: *Apples*

Cross
Hatching

Oranges with Wine Glass

The quality of drawing with Conté pastel pencils is seen in the colour picture opposite, where the segments of an orange are drawn in a few simple lines on green paper. I used two shades of brown and some pink and white for these parts of the drawing.

The green of the paper shows through the open lines to suggest the dull shine from the cut pieces of orange. The wine glass shows the same economy of drawing, which allows the green paper to show through.

I used the same colours for the partly opened oranges; this time the lines were applied close together, sometimes just touching and sometimes overlapping to give a more solid coverage of pastel pencil.

The background and shadows consist mainly of criss-cross lines but, here and there, of some sideways strokes of brown Conté crayon. This was the solid square stick Conté crayon which can be dragged over the paper, using the flat side to produce areas of colour. I used it particularly in the immediate foreground.

The other drawing reproduced here in black and white has very little solid colour. I wanted to concentrate on lines to convey the boat-like shapes and the square-cut edges of the orange peel.

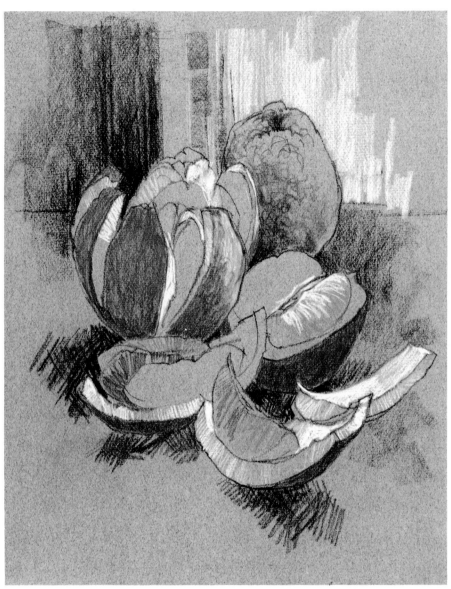

(above) Pastel pencils on Ingres paper: *Oranges*
(right) Pastel pencils on Ingres paper: *Oranges with Wine Glass*

Perspective

Some knowledge of the rules of perspective is essential if you are to draw a three-dimensional object on a flat piece of paper. Basically, the further away an object is from you, the smaller it appears. Parallel lines may never meet in practical fact, but in perspective they appear to do so, and they appear to do so at a point on the horizon known as the vanishing point. The horizon corresponds to individual eye level: if you stand up to draw, the horizon will be higher than if you sit in a low chair; correspondingly the vanishing point will relate to the drawing position.

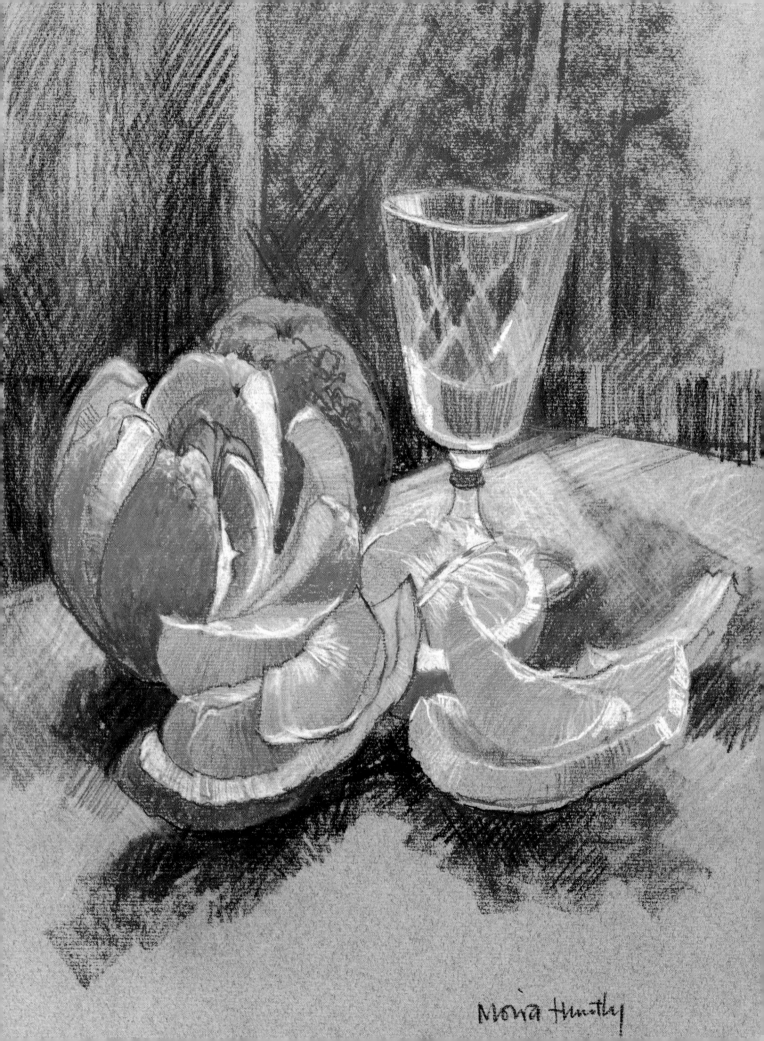

Moira Huntly

A few rules

1 Vertical lines remain vertical.

2 *On* your eye level (provided that the head is held erect), all lines that are parallel to the ground appear horizontal.

3 *Above* your eye level, lines parallel to the ground will appear to slope *down* as they recede to the horizon.

4 *Below* your eye level, lines parallel to the ground will appear to slope *up* as they recede to the horizon.

It is worth spending a little time looking for perspective angles before you start to draw.

Straight lines

Fig. 1 If I prop up my drawing board so that it is vertical, I can draw it as a simple rectangle, each corner a right-angle and each side virtually the same distance from me.

Fig. 2 When I lay the board down on the table, with the two nearest corners equidistant from my eyes, side B looks smaller than side A because it is now further away. The other two sides are in fact parallel but appear to be getting closer together as they recede. (Lines drawn from them into the distance would eventually meet at a vanishing point on my eye level.)

Fig. 3 This diagram shows a box below my eye level, so all lines parallel to the ground are travelling *up* to the horizon (at my eye level). All the upright sides of the box remain vertical, of course.

Fig. 4 If I now move the board shown in Fig. 2 like a turntable, this alters the corner angles. Sides C and D, which are in fact parallel to each other, are no longer receding into the distance directly in front of my eyes as in Fig. 2 but are travelling towards a vanishing point on the horizon somewhere to my left. Sides A and B form their own pair of paallel lines receding towards a vanishing point, but in their case somewhere to my right.

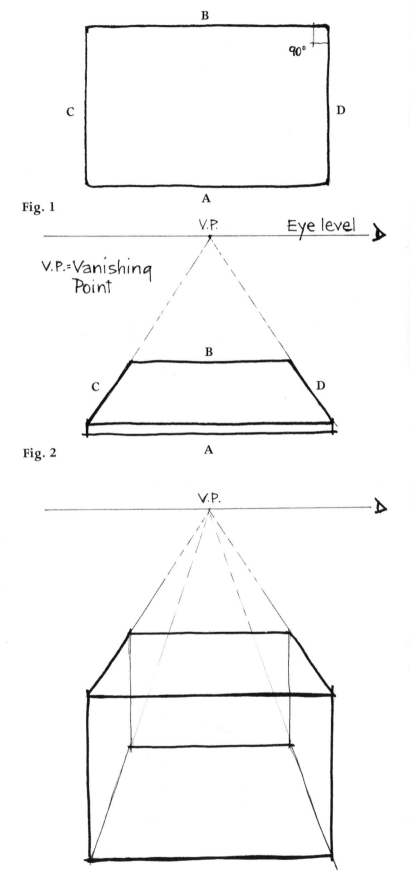

Fig. 1

V.P.=Vanishing Point

Fig. 2

Fig. 3

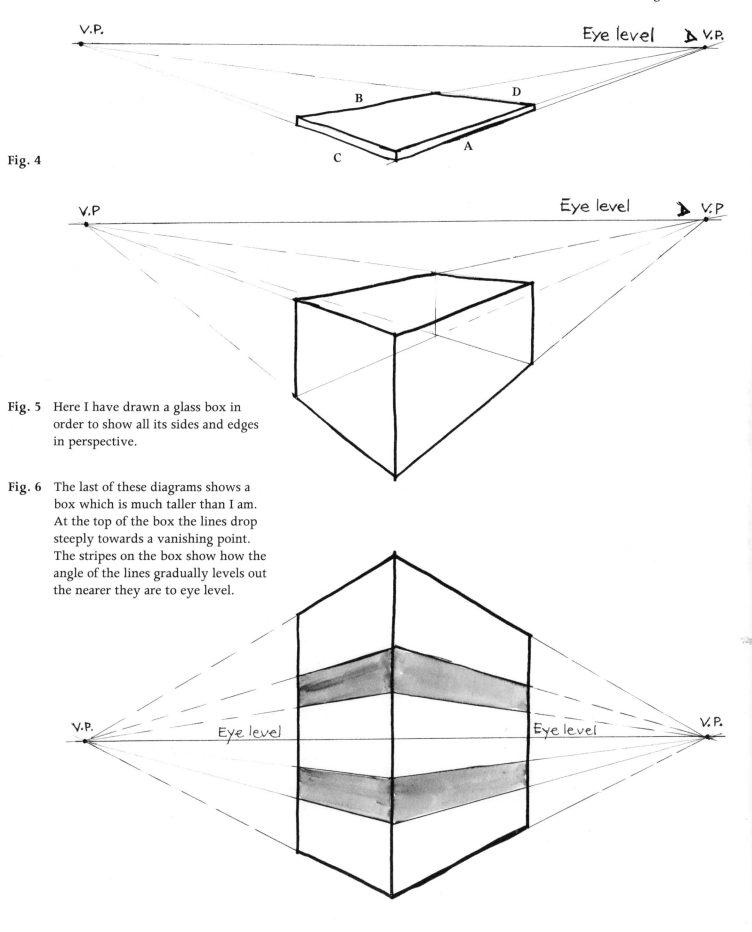

Fig. 4

Fig. 5 Here I have drawn a glass box in order to show all its sides and edges in perspective.

Fig. 6 The last of these diagrams shows a box which is much taller than I am. At the top of the box the lines drop steeply towards a vanishing point. The stripes on the box show how the angle of the lines gradually levels out the nearer they are to eye level.

Perspective

Curves

Fig. 1 This time my vertical board is square, with a circle drawn on it. The two halves of the circle, marked A and B, are equal in size because they are at the same distance from me.

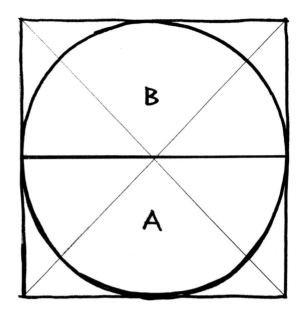

Fig. 2 As soon as the board is tipped away from me, the semi-circle B is further away and therefore appears smaller than A – and the circle becomes an ellipse.

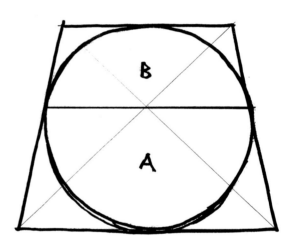

Fig. 3 The ellipse gets narrower when the board is laid flat. No matter how small the ellipse, the nearer half (A) will always be slightly larger.

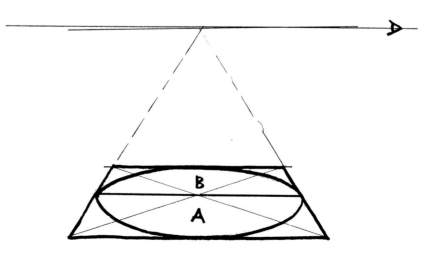

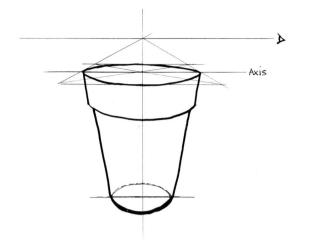

Fig. 4 The principle applies to all circular objects: here I apply it to flower pots. It is helpful to draw in the axis lines lightly so that the widest points of the ellipse are opposite each other, for otherwise a pot will look lopsided.

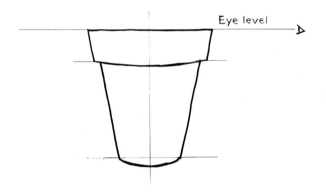

Fig. 5 The top of the flower pot is raised to my eye level so that I cannot see inside and the circular rim looks like a straight line. The next line down is very slightly curved because it is only just below eye level, while the base line of the pot is the most curved because it is lower still. In fact the lower the pot is, and the more you can see into it, the more circular the ellipses will become.

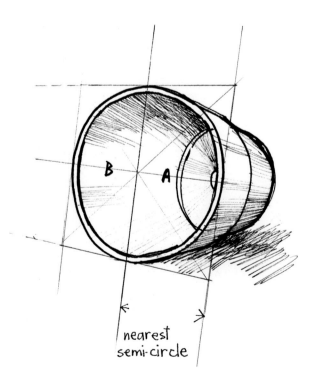

Fig. 6 The same rules of perspective apply when you are drawing a pot on its side. The nearest semi-circle will always be the largest.

Plant Pots

There are plenty of ellipses to draw in this group of plant pots. I used a dark brown pastel pencil and lightly indicated the outlines of the pots, taking note of their different levels and widths. The ellipses of the pots on their sides were more difficult to draw but I tilted my head so that I could view them as if they were upright. In this way, it was easier to correct any faults in the drawing.

Some of the pots had deep shadows. These I gradually built up with cross-hatching and by working in black pastel pencil with the brown. The use of both black and brown in a drawing of this kind adds richness and warmth.

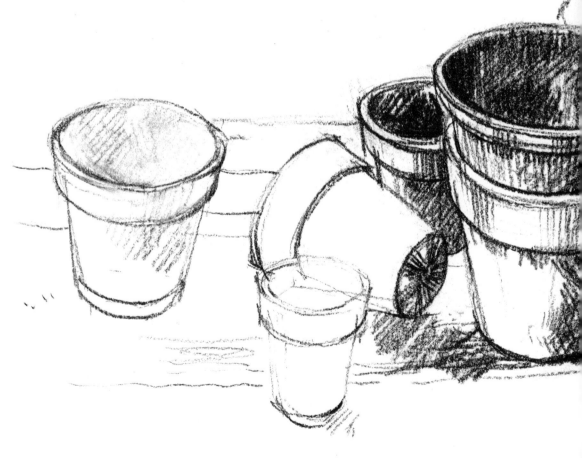

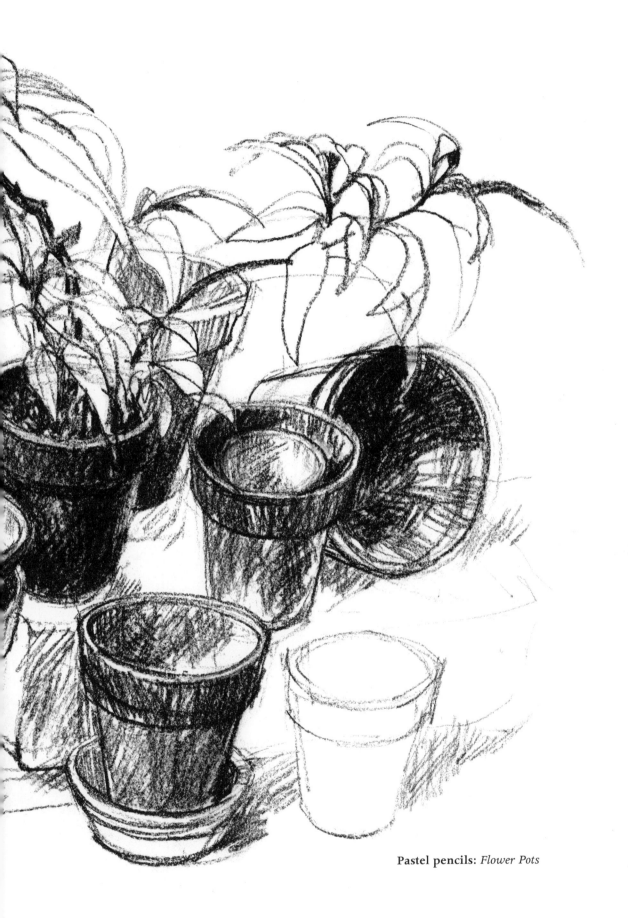

Pastel pencils: *Flower Pots*

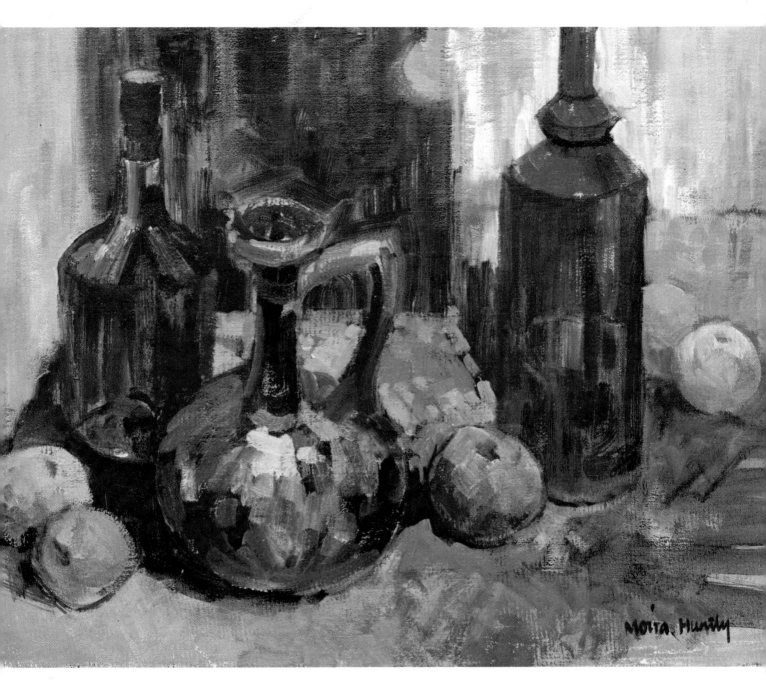

Oil: *The Blue Bottle*

Oils

Oil paint is a good medium for beginners. There is a freedom about the medium – especially a freedom to rectify mistakes – which is important because it gives confidence. The quality of oil paint is such that it can be pushed around with brushes, knives or 'turpsy' rags: Titian and Rembrandt are known to have used fingers, thumbs or brush handles on some parts of their paintings. But it is easy to get into a mess and ruin equipment if work is not methodical, particularly when it comes to the cleaning up after each painting session!

The painting shown opposite was a demonstration painting to a class. I had placed the bottles and the fruit on the table with the intention of making a formal arrangement for the painting. Then I thought that they looked interesting as they stood: the green and blue bottles close together and the brown bottle apart. I liked the shape of the background shadow and the shape of the fruit echoing the sphere of the blue bottle. I also liked the shimmering colours in the blue bottle against the subtle greys and pinks of the table.

I spent little more than an hour on this demonstration painting, and perhaps it could be tidied up, but I think that it does possess a vitality of brushwork which is consistent with the vibrant colour of the blue bottle.

Oil painting is a strong positive medium which lends itself to decisive patterns, with combinations of crisp and broken edges. This vitality and aggressiveness pleases me more than a highly finished work.

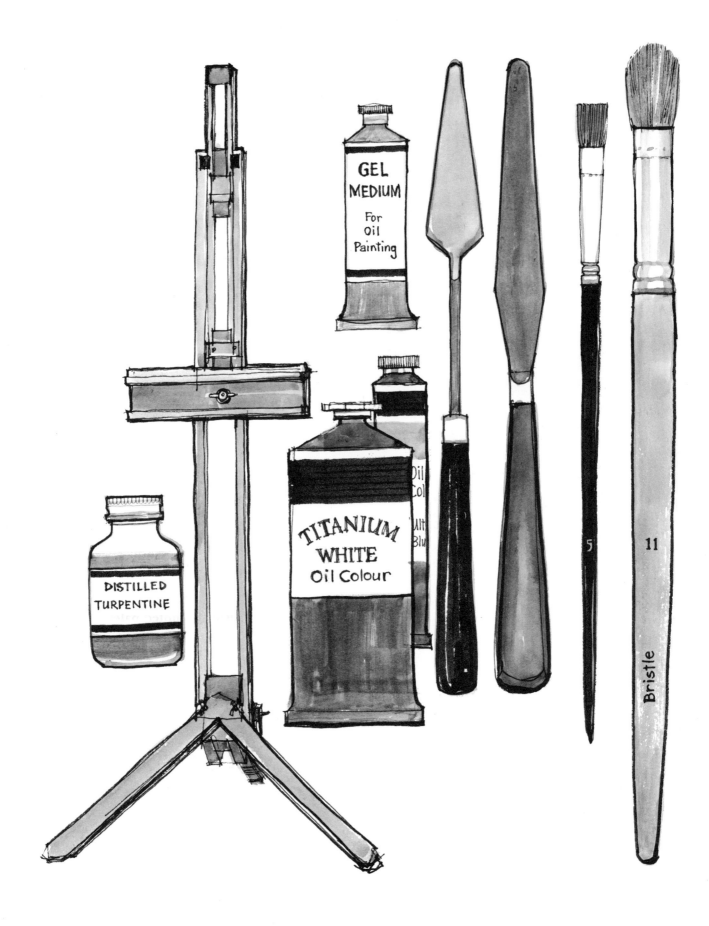

GEL
MEDIUM
For
Oil
Painting

DISTILLED
TURPENTINE

TITANIUM
WHITE
Oil Colour

Oil
Col

ult
Blu

5

11

Bristle

Materials

Painting surfaces

There are a number of different surfaces, also called supports, on which you can paint in oil. All surfaces have to be sized and primed to make them impervious to oil.

Canvas
The most commonly used support, which can be obtained stretched and ready primed.

Canvas board
This can be obtained ready primed.

Hardboard
It is best to sandpaper the smooth side to remove the shine and then prepare with two or three coats of size.

Wood
This should be well seasoned, or aged, and at least an inch (2.5 cm) thick. Like hardboard, it must have a smooth but not shiny surface and be properly sized.

Chipboard
Muslin may be glued to it and then very well primed.

Plywood, strawboard or heavy cardboard
Any of these will have to be sized on both sides to prevent warping.

Copper or aluminium sheet
No preparation is required apart from sanding down.

If you prepare your own boards or canvases, it is important to prepare them well – and it makes sense to prepare several at once.

First the surfaces have to be sized. Size can be bought from a hardware shop and used according to the manufacturers' instructions. It should be brushed well into the surface.

After being sized, the surface has to be primed. The primer can be either a proprietary brand of oil primer or two thin coats of emulsion paint, although many professional artists prefer to prepare their own primer.

Tools and other materials

Brushes
It is important to have a choice of small, medium and large brushes. A basic selection could be

1 small flat brush (no. 4)
2 medium filbert-shaped brushes (no. 6 and no. 8)

and 1 large round brush (no. 11) and this collection could later be built up to 20 brushes or more. I sometimes use an inch (2.5 cm) wide house painting brush for large areas and a fine sable brush for detail.

Palette
This, also, must be impervious to oil. And it should not be too small – it takes room to mix paint. The traditional palette is made of clean wood that has been treated with linseed oil several times.

Alternatively, the palette can be a thick piece of glass or a piece of formica or other plastic laminate.

Palette knives
These are essential for mixing paint on the palette. Various shapes and sizes can also be used for applying paint.

Dippers, turpentine/white spirit, medium – and plenty of rags!
Dippers are small containers for holding oil and turpentine. Turpentine substitute or white spirit is used for thinning paint and for cleaning purposes. Medium is mixed into the paint if required to make it flow more easily. There is a variety obtainable.

Easels

There are many types to choose from according to individual requirements and the space available. If there is no room for an easel, then the board or canvas can be supported on a table or on the lap (see page 33).

Paint

Using a limited palette
From only a small range of basic colours many colour mixes can be produced. The choice of basic colours will depend on individual taste and purpose. The following palette is very useful:

CADMIUM YELLOW ULTRAMARINE BLUE
YELLOW OCHRE VIRIDIAN
CADMIUM RED BURNT UMBER
ALIZARIN CRIMSON BURNT SIENNA

TITANIUM WHITE (greater opacity and brilliance but slower drying than FLAKE WHITE)
LAMP BLACK

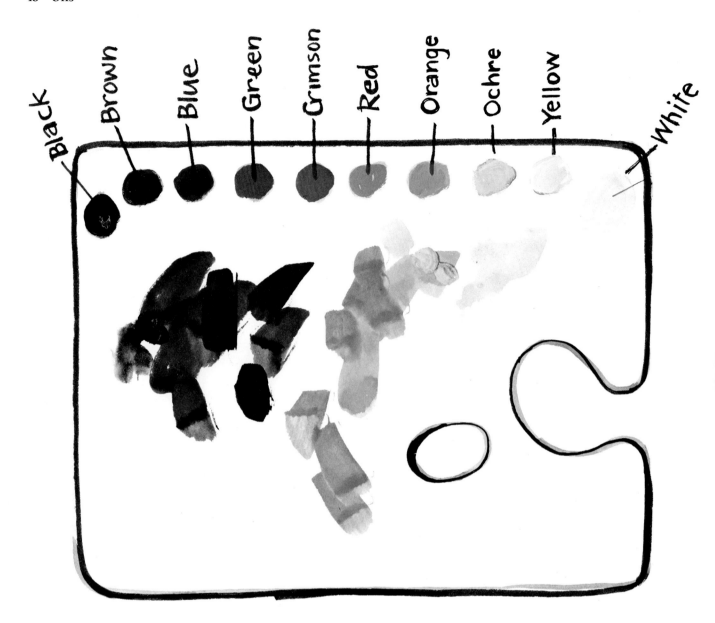

The following can be added later:

LEMON YELLOW

RAW SIENNA

MONASTRAL or PRUSSIAN BLUE

CADMIUM ORANGE

Since light colours are more quickly used up, it is more economical to buy a larger size tube, especially of the white.

Black is an uninteresting colour, best avoided in underpainting or on its own as it has a tendency to dry matt and to look dull. A good rich dark can be better obtained by mixing, for example, burnt umber with ultramarine blue or vermilion with Prussian blue. However, black can be useful when added sparingly to darken other colours.

Most of today's oil paints can be used straight from the tube. It already contains the right amount of oil and it is not necessary to add any more. There are various modern quick-drying thixotropic gel mediums on the market which will make the paint flow more easily, should that be required, and which I think are preferable to linseed oil. (Oil is slow to dry and tends to yellow.)

Starting to paint

Be careful and consistent about the placing of colours on the palette to avoid confusion. For instance, dark pigments can look alike at a glance but if they are always in the same order on the palette it is easier not to pick up the wrong one on the brush. It is best to set the colours out along the top edge and to leave the rest of the palette clear as a mixing area.

Put out just the colours that you know you want to start with. Squeeze out a small amount if the colours are dark and larger amounts if the colours are light – especially of white. Dark colours are strong and a little goes a long way, whereas greater quantities of paint will be needed for light areas. Squeeze paint tubes from the base and replace the caps immediately.

If you are mixing a light colour, start with the light pigment and gradually add the darker pigment to it. An infinitesimally small amount of red will change white to pink, whereas half a tube of white would be required to change a large amount of red to the same shade.

While it may seem obvious, it is important to look after brushes by cleaning them immediately after use. Rinse out the paint in household turpentine and then wash the brush with soap and water. Work up a lather with the brush on the palm of your hand and then rinse in water. It may be necessary to repeat the lathering several times until the colour stops coming out of the brush. Rinse frequently. Finally shake the excess moisture from the brush and smooth it gently back into shape.

Clean off the palette with a palette knife and then wipe it with a 'turpsy' rag. A fair amount of excess paint can be kept under water but only if you want to use it again the next day.

The dippers should be emptied and then cleaned with a 'turpsy' rag.

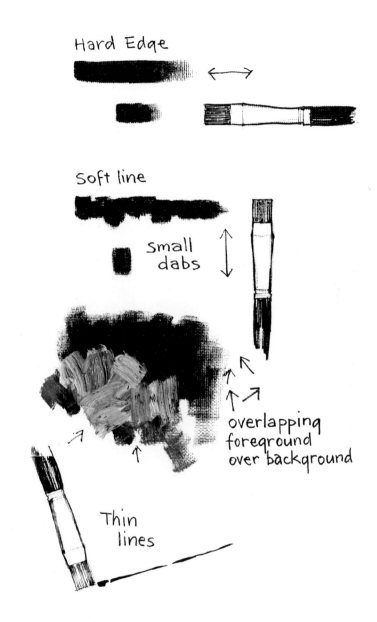

Hard Edge

Soft line

small dabs

overlapping foreground over background

Thin lines

Brush marks

Brush marks vary according to the size and type of brush. It is worth experimenting with flat, filbert and round brushes to discover their particular characteristics. The marks in the diagram were all made with the same brush (no. 4 flat).

DEMONSTRATION IN OILS:
Onions on a Red Cloth

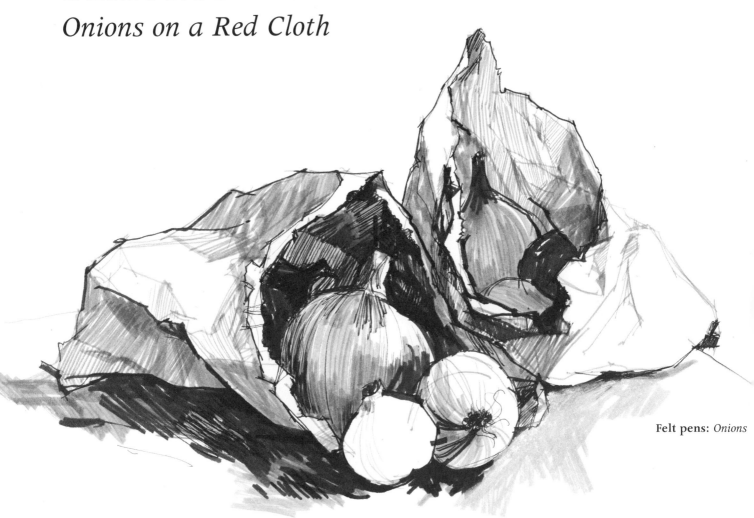

Felt pens: *Onions*

The purpose of this demonstration is to show a traditional method of oil painting, which starts with a foundation of thin paint and where the thickness of the paint is gradually built up as the painting progresses.

Looking for a simple subject in the kitchen, I noticed that the opened paper bags full of onions made some interesting shapes. The angularity of the creases in the paper were a contrast to the simple rounded form of the onions.

Before starting, I rearranged the two large onions that had tumbled out of one paper bag by moving them about until I liked the shapes of the spaces between the onions and the bags. In other words, I was looking at the background of the red tablecloth as a shape in itself. It is just as important to look at the spaces between objects as at the objects themselves.

Materials

Hog hair brushes nos. 1 (flat), 3 (round) and 8 (flat).
Fine grain canvas.
Palette: ultramarine blue, burnt umber, vermilion, alizarin crimson, cadmium yellow, lemon yellow, titanium white.
Turpentine substitute/white spirit.
Rags.

STAGE 1

I draw directly on to the canvas with the smallest brush and a mixture of ultramarine blue and burnt umber, well thinned with turpentine. The first lines are very pale but I increase the strength of the paint as I become more sure of the arrangement I want. At this point some of the areas of shadow are filled in with a larger brush and any unwanted lines removed with a rag dipped in turpentine.

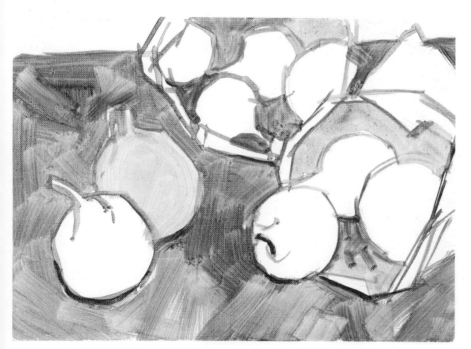

STAGE 2

My main aim now is to get rid of the distracting areas of white canvas as quickly as possible. I paint in the red cloth with the largest brush and a thin mixture of alizarin crimson and a touch of burnt umber, then the onions with cadmium yellow or lemon yellow. This method of thin underpainting helps me to see relationships between objects quickly and the painting as a whole. If I am not pleased with it, I can easily wipe off the paint and make alterations.

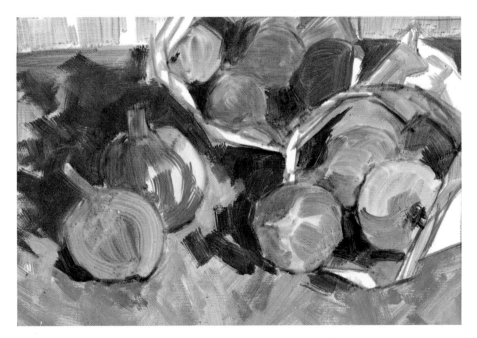

STAGE 3

I continue to fill in the areas of colour, gradually reducing the amount of turpentine used to mix the paint. The darker tones in the shadows on the table are painted with alizarin crimson and burnt umber, some of the onions with a mixture of cadmium yellow and burnt umber. As the tones are darkened in places the painting becomes more three-dimensional because there is a greater feeling of light and shade.

The next stage is easier if the painting can be left to dry overnight.

STAGE 4

With the underpainting dry and the dark areas established, I start to mix fresh paint – this time straight from the tube (no turpentine). I complete the background and table top, building up the light areas with the thicker paint and carrying it well into the edges of the onions and paper bags. I use titanium white with a small amount of alizarin crimson, introducing touches of burnt umber and vermilion to vary the tones. For the tablecloth I introduce a little of another red, which adds a certain vibrancy to the painting. The insides of the paper bags are painted next, with mixtures

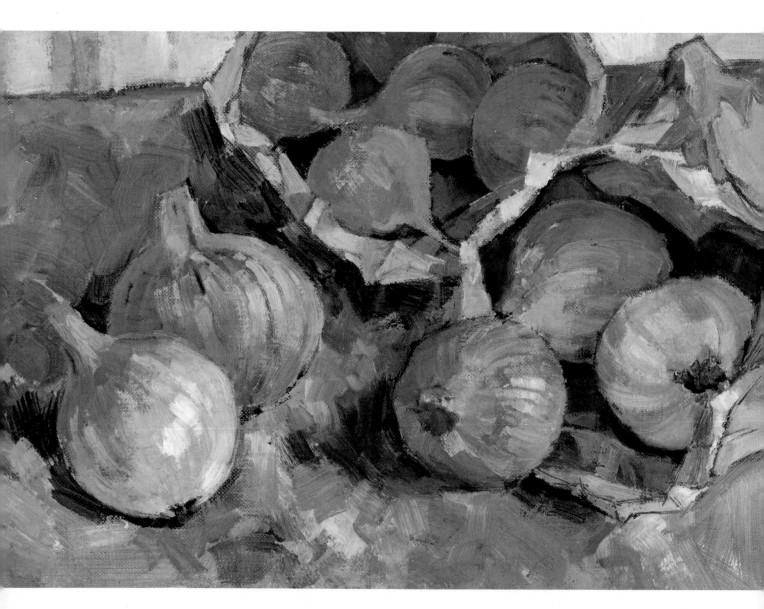

of burnt umber and ultramarine blue, adjusted with small amounts of white or yellow to vary the dark tones.

I then start to refine the brush work, building up with thicker paint. Notice that I have now overpainted the brush strokes of the previous stage, letting adjacent strokes overlap so that they blend. I have also corrected certain tones – particularly the white in the paper bag.

I save the highlights until last, being careful not to use white paint by itself but tinting it very slightly with yellow ochre. This gives the highlights a warmth that prevents them from being too stark and disruptive in the painting.

The last stages of a painting are often the most difficult, for it is not easy to decide on the final adjustments to shapes or colours which will achieve an overall unity. Sometimes I leave a painting in the hall or kitchen where I can see it each time I walk past. By so doing, I often get a sudden inspiration that shows me how to finish the painting.

Colour

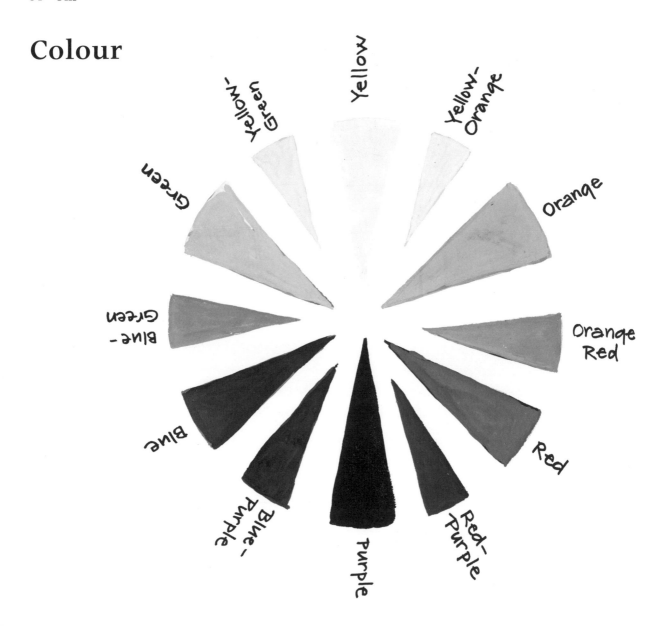

Knowing how to mix colours and to relate them to each other is an essential part of painting. A good composition can be spoilt by a poor choice of colour or by a confusion of colour. One of the most difficult things to develop is the ability to judge the tonal value of a colour and to decide how warm or cold it is.

Tone value of colour

The tonal value relates to the amount of light or dark that a colour possesses. The colour circle shows how the basic colours vary in tone.

Temperature of a colour

Warm colours are easy to imagine. Just think of the glowing red embers of a fire and the yellow and orange flames. Why do children automatically paint the sun yellow? As for cool colours: people often say that they are 'blue with cold' or long in summer for the cool of some leafy green shade.

Properties of colour

Strong tonal contrasts come forward in a painting: for instance, a very pale colour when placed next to a very dark colour will attract attention. The use of warm and cool colours to achieve recession in a painting is known as aerial perspective. Cool colours recede and warm colours come forward.

Harmonies

To be sure that colours will not clash when placed next to each other, choose harmonies. Colours that harmonise are found next to each other on the colour circle, e.g. blue and blue-green, or red and red-purple.

Complementary colours

Colours that are complementary are found opposite each other on the colour circle, e.g. blue and orange. Black and white are the most obvious opposites and give the strongest tonal contrast. The qualities and use of complementary colours are important in a painting. One made up only of different shades of green would be boring without a touch of complementary colour to relieve it – for greens, this would be a speck of red.

The eye naturally requires some contrast. Hold a bright green square of colour against a white background and stare hard at it for a few minutes. When the square is removed, a pink area will gradually appear on the white ground. The eye is automatically seeking a contrast.

If, however, a picture is painted with equal amounts of complementary colours such as red and green, there is too much contrast and the painting becomes confusing to the eye.

Neutral colours

Complementary colours mixed together in equal proportions cancel each other out and produce a neutral grey. This applies to purple and yellow, blue and orange or red and green. Variations of neutrals can be obtained if complementary colours are mixed together in unequal proportions so that there is a bias towards one of the basic colours.

An awareness of the properties of colour becomes an automatic part of the thinking process for the painter. It can only be developed through practice. But once it has been developed and made individual it creates endless possibilities for exploration – the possible range of effects from the use of colour is unlimited.

Colour ideas

Still life painting offers ideal conditions for the exploration of colour. A group of objects is usually available indefinitely and can be made the subject of more than one painting. It is interesting to interpret the same still life group with a different colour emphasis. Below are a few suggestions for ways of using colour. (These are not confined to oil painting but are suitable for any medium.)

1 A limited range of colour

This can give unity to a painting where too wide a range of colour would be confusing. Titian, for example, often used only three or four colours plus black and white.

2 Primary colours

Try painting with a palette of pure primary colours – red, yellow and blue – with no browns, blacks, earths or greys. In the early twentieth century a group of painters called the Fauves experimented with colour in this way. The group included such painters as Derain, Rouault and Matisse.

3 Muted colour

In complete contrast to the work of the Fauves, there are paintings where the three primary colours have been used in a muted form: yellow ochre instead of bright yellow, burnt sienna instead of red, and indigo instead of blue – with the addition of raw umber and lamp black to the palette.

4 Limited range of tone

It is possible to paint still life subjects with very little contrast or tonal range. One version could be a 'high key' painting which exploits all the light tones and no strong darks at all.

Coloured grounds

Painting on a prepared coloured ground is another traditional method of painting – which may help a beginner to make a start by removing the frightening expanse of white canvas and by allowing him the feel of putting paint on freely as he covers the canvas.

When I am preparing a ground, I cover the support with paint thinned with turpentine or white spirit, using a large 1″ or 2″ house painter's brush (depending on the size of the canvas). Sometimes the paint is a mixture of an earth colour and a cool colour, e.g. raw sienna and ultramarine blue, or burnt umber and Prussian blue. On other occasions, I like to work on a warm ground of burnt sienna, or perhaps an entirely cool ground of viridian mixed with ultramarine blue.

The demonstration painting, *Plant on a Window Sill*, described on the next four pages, is an example of the 'coloured ground' way of working. The final painting consists mainly of cool colours, but I started with a warm ground. This shows through in places and emphasises the cool colours, thus providing relief to the eye.

DEMONSTRATION IN OILS ON A COLOURED GROUND: *Plant on a Window Sill*

It was the play of light on this group of leaves and apples that attracted my eye. Cool greens and cool blues were interspersed with pearly lights and flashes of almost pure white.

Materials
Hog hair brushes nos. 4 and 7 (flat), 11 (filbert), 5 (round); also a 1″ house painter's brush.
Prepared hardboard.

Palette: burnt umber, raw sienna, lemon yellow, alizarin crimson, titanium white, viridian, Prussian blue, ultramarine blue, terre verte.
Turpentine substitute or white spirit.

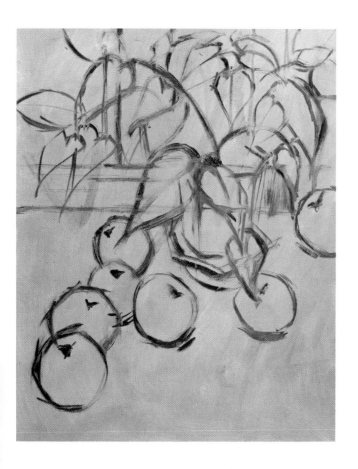

STAGE 1

The ground is painted thinly with a mixture of alizarin crimson and burnt umber thinned with turpentine, using a 1″ brush. This is left to dry for a day.

The subject is drawn in freely with a medium brush and a mixture of viridian and burnt umber. As the outlines will not be precisely correct first time, the paint is thinned with plenty of turpentine. This allows me to alter the drawing as much as I like until I am satisfied with it. If necessary I can remove unwanted lines with a 'turpsy' rag. When I am sure of what I want, I can draw more boldly with thicker paint.

STAGE 2

Using a large filbert brush I fill in more areas with thinned dark paint and gradually build up the tones of the underpainting. I indicate the shadows cast by the apples, and the tone of the leaves against the window pane.

(STAGE 3 on page 60.)

I was attracted to the strong and angular shape of the leaves and to the way the pot echoes this angularity. The spaces between the leaves are also interesting. I instinctively look for such abstract qualities in a subject because it is they that give individuality to a painting. The plant is design and pattern as well as just leaves. The rounded shapes of the apples introduce a foil to the angular shapes of the plant and the pot.

The detail opposite from the finished painting on page 61 shows the build-up of thick light paint on darker ground. It also shows the counterchange of a light leaf against the dark shadow on the pot, and then the reverse – a dark leaf against the light surface of the pot.

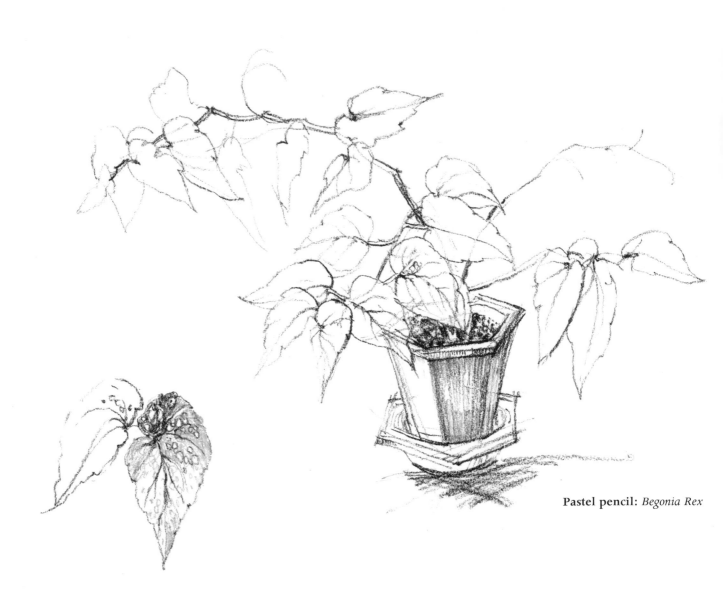

Pastel pencil: *Begonia Rex*

Full-size detail from Stage 5

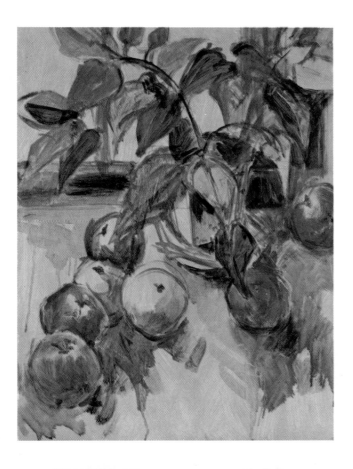

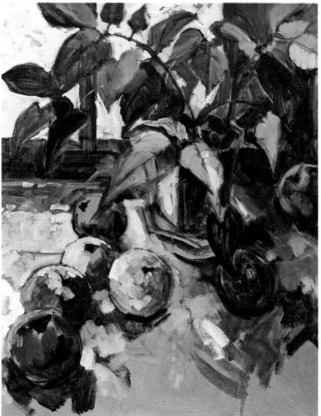

STAGE 3

The underpainting of some of the apples is strengthened with another application of thin alizarin crimson, and the darks on the leaves are strengthened further with mixtures of burnt umber and Prussian blue, burnt umber and terre verte, and raw sienna and ultramarine blue.

STAGE 4

I paint the background with a medium-sized flat brush and full thickness of paint (no turpentine). The strong light shapes between the leaves are painted with a mixture of white and a small amount of ultramarine blue and umber; in other places, white with a touch of Prussian blue. The light paint makes the leaves appear very dark and contrasty, but this will be adjusted to a softer tonal contrast when I paint the leaves later. The same light colours are repeated on the window ledge and the cloth, softened by using slightly less white in the mixture. This lowers the tone. Some of the dusky pink ground is allowed to show through here and there.

STAGE 5 — THE FINAL STAGE

Many adjustments have been made to the tones. Some of the dark leaves now have light catching them and the lighter tones of the various greens used softens the sharp contrast of the leaves against the light.

Some leaves are painted so that the original dark underpainting is left to show through as veins.

In this painting I have used two different blues, two greens, two yellows and white. It is an interesting exercise in itself to see how many different greens result from the mixing of these colours in varying proportions. But these are all cool colours and to offset them, I have painted the shadows with warm colour — hints of amber and mauve.

As I progress with the painting, I become more and more interested in the light, in fact the painting is about the interplay of light.

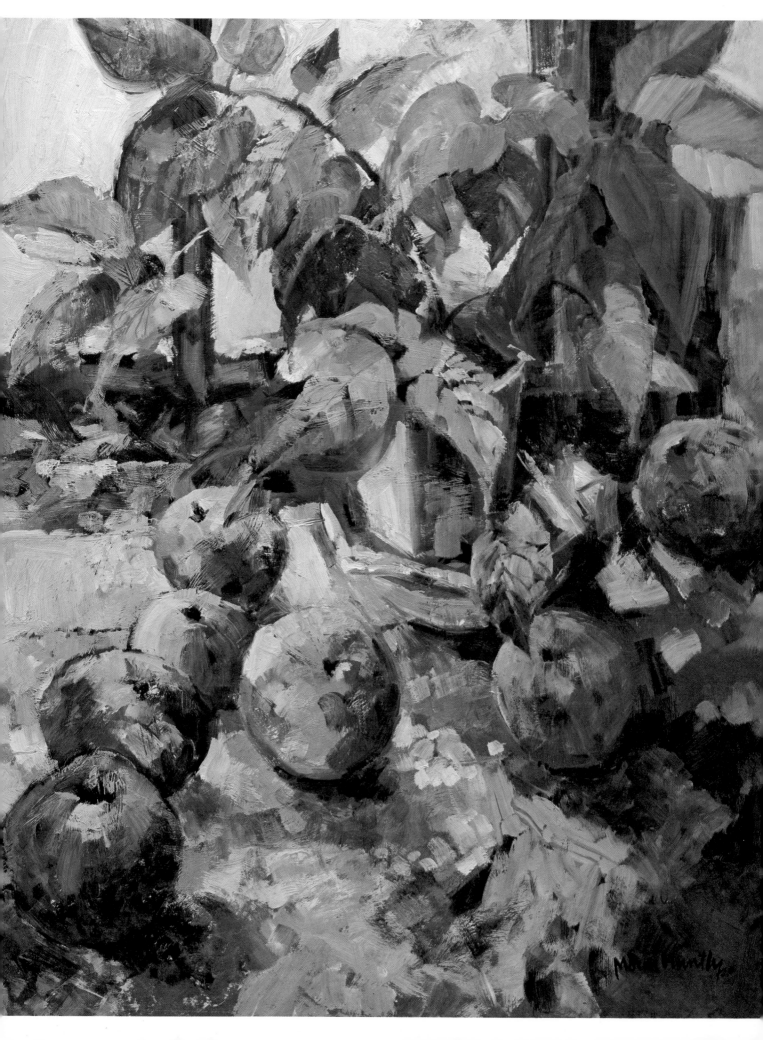

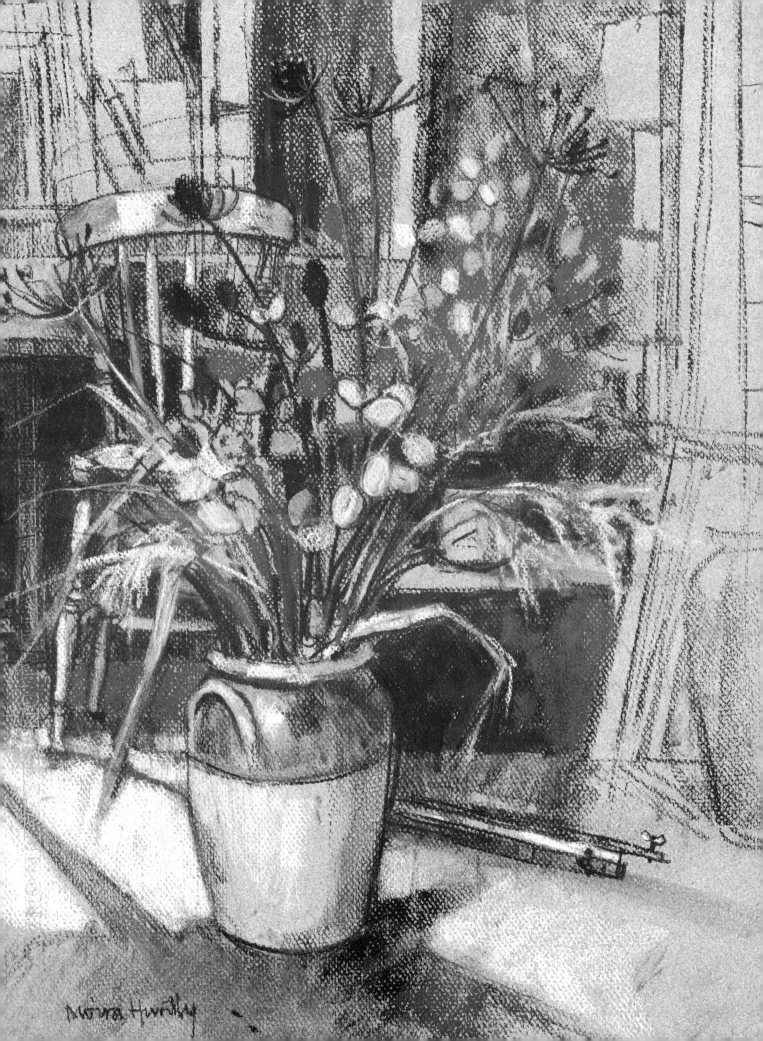

Moira Huntly

CHAPTER FOUR

Charcoal

Charcoal is one of the oldest drawing mediums – in fact, it was used by the prehistoric cave men. It is basically just burnt wood. Nowadays artists' charcoal is produced in special kilns so that the wood, usually twigs of willow, is evenly burnt.

Throughout the ages artists have enjoyed the drawing qualities of charcoal. It is good for large-scale work and for covering large areas with tone; it is also good for achieving subtlety in a drawing. Thick pieces of charcoal can be pressed on to the surface heavily to give a rich dark, and fairly fine lines

can be achieved with the tip of thin pieces of charcoal.

Charcoal drawing looks good on coloured papers. Because it remains loose on the surface, a charcoal drawing needs to be sprayed with a fixative so that it does not rub off.

Charcoal is also useful for preliminary drawing under a pastel painting. Many artists use it to outline the subject on the canvas in preparation for oil or acrylic paintings.

The charcoal 'painting' opposite was on Canson Ingres paper, which has a

strong texture. I used the tip of a thin stick of willow charcoal for the preliminary drawing and then broke a piece off and used the side of the stick for some of the shadow areas in the background. The light tone in the background was provided by the paper, and the stronger lights in the foreground were filled in with white Conté crayon.

The picture is of a corner of the studio, but what attracted me was the pattern of light and shade on the floor and the dappled lights of the seed pods of the plant we commonly call honesty (*Lunaria*).

(opposite) Charcoal: *A Corner of the Studio*

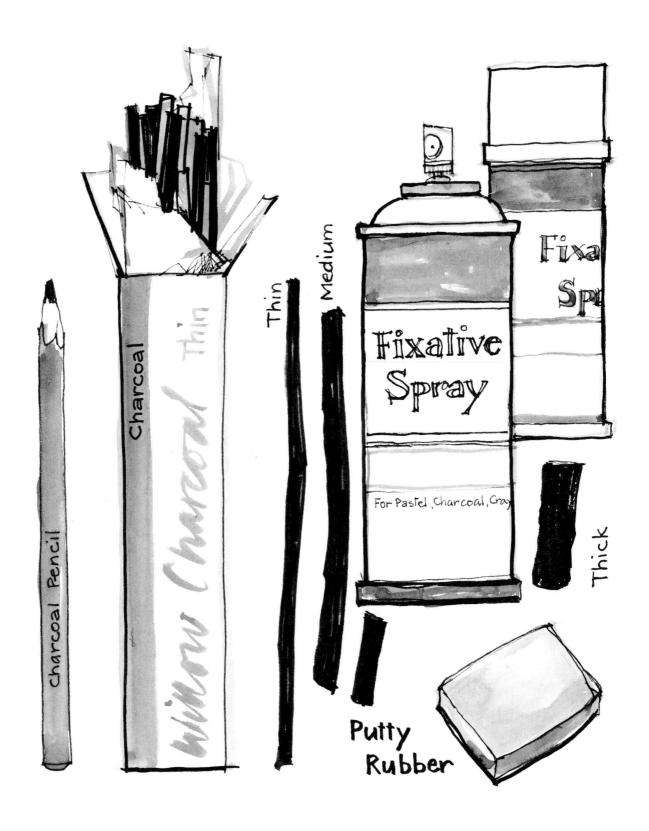

Charcoal Pencil

Charcoal

Willow Charcoal

Thin

Thin

Medium

Fixative Spray

Fixa Spr

For Pastel, Charcoal, Crayon

Thick

Putty Rubber

Materials

Charcoal

Sticks of charcoal in different
thicknesses and degrees of
hardness.
Shorter, thicker sticks of compressed
charcoal.
Charcoal pencils of compressed
charcoal come in soft, medium or
hard quality. They are easily
sharpened and are useful for more
detailed drawing.
Charcoal can be combined with
watercolour, gouache, ink or
Conté crayon.

Paper

Pastel paper (available white and
coloured) or watercolour paper,
for textured effects.
Cartridge paper for smoother effects.

Putty eraser

Mistakes in a drawing with charcoal
can be blown away easily or rubbed
off with a putty eraser. A putty
eraser (or even a piece of bread) can
also be used to lift out highlights in a
drawing.

Fixative spray

Since charcoal can be smudged or
removed so easily, it is important to
use a fixative spray on a finished
drawing.

Techniques

1 Lines drawn with the tip of
charcoal sticks of different sizes.

2 Using the side of a broken off
piece of charcoal and dragging it
lightly downwards.

3 Using the side of the charcoal, as
in diagram 2, and applying more
pressure.

4 Filling an area by exerting light
pressure on the side of a piece of
charcoal.

5 Making lines with the long edge of
a piece of charcoal.

6 Filling in a solid dark with the end
of a thick piece of charcoal.

DEMONSTRATION IN CHARCOAL:
The Shell

The purpose of this demonstration is to create a fully tonal 'painting' in charcoal, rather than just a drawing. Working on a darkened background and looking for the light areas helps to develop awareness of the modelling effect of light falling on solid structure.

Materials

Stick willow charcoal, thin and medium.
Saunders (NOT surface) watercolour paper.
Putty eraser.
Fixative spray.

STAGE 1

I cover the paper completely with a layer of charcoal, using the side of a medium stick and blending it slightly with my finger or a stump of rolled paper.

STAGE 2

After making sure that my sleeve is out of the way, I draw in the outline of the shell with a thin stick of charcoal. At this stage, I ignore most of the detail and keep the drawing very simple.

If I make a mess of the drawing, I can rub it over with the side of the charcoal and blend it into the background ready to start again. This can be done several times if necessary.

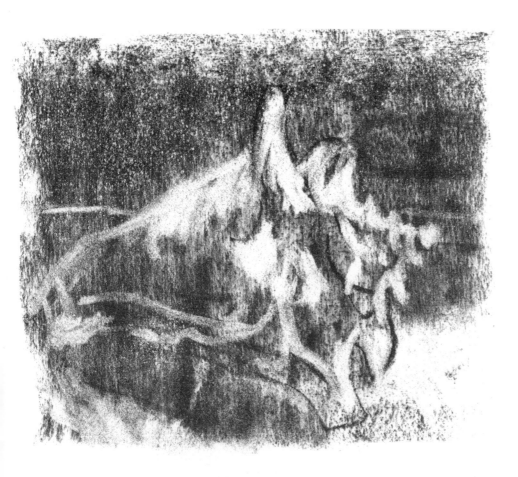

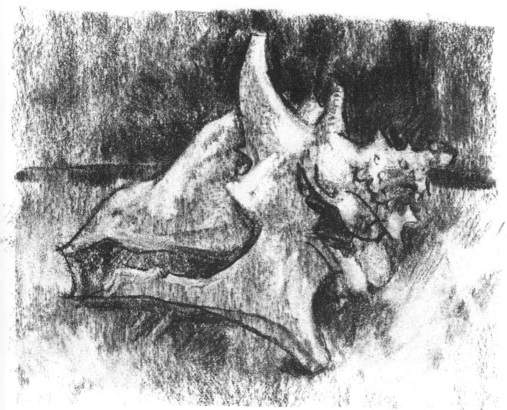

STAGE 3

I look at the shell through half-closed eyes in order to see where the light falls most. The 'lights' are achieved by lifting off the charcoal with the edge of a putty eraser to expose the white paper. A small piece of bread can be used instead of the putty eraser but must first be compressed by kneading. The rubber must be kept clean – or the bread turned – so as to avoid putting back on to the drawing the charcoal that has just been removed.

STAGE 4

I now strengthen the drawing and make a few adjustments to the light and shade with the charcoal stick and the putty eraser. The marks by the side of the drawing show where I clean the rubber. The study could be made more detailed by adding to it with a charcoal pencil. When I am satisfied that I have included all the lights, then I can spray. It is possible to add more charcoal after spraying but it is not easy to remove with the rubber charcoal that has been fixed.

This method of applying charcoal allows full use of chiaroscuro (the balance of light and shade). To achieve the right effect it is necessary to judge the tones of the various shadows correctly.

DEMONSTRATION IN CHARCOAL AND WATERCOLOUR:
The Kitchen Table

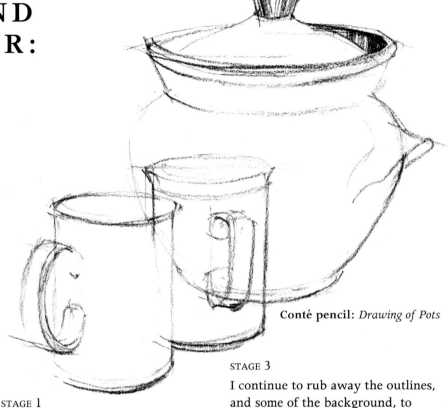

Conté pencil: *Drawing of Pots*

This demonstration combines charcoal with watercolour and develops the process used in the charcoal drawing of the shell. Instead of applying charcoal to white paper, I colour the paper first with watercolour washes. When charcoal is rubbed away the colour wash is revealed.

Materials

Stick willow charcoal, thin and thick.

Bockingford 140 lbs (285 g/m²) watercolour paper.

Squirrel hair watercolour brush no. 12 and a soft flat 1″ watercolour brush.

Watercolours: raw sienna, neutral tint, cyanine blue, permanent yellow, burnt sienna.

Putty eraser.

Fixative spray.

(If the piece of paper is large, it has to be stretched before use – see page 109).

STAGE 1

Using the soft flat 1″ brush I damp the paper with clean water. While it is still damp, I start brushing on some very loose washes of warm colour with the no. 12 brush and quickly add washes of cool colours with the flat brush. Although the washes are freely painted, there is just a hint of the large pot and fruit formations if you look carefully.

STAGE 2

When the washes are dry, I cover the paper completely with charcoal (except the apple area which I have left uncovered for the purpose of this demonstration – to illustrate the sequence of working). With a putty eraser kneaded to a sharp edge, I draw lines through the charcoal to outline the objects, continually cleaning the rubber on a scrap of paper as I work.

STAGE 3

I continue to rub away the outlines, and some of the background, to reveal the colour washes underneath. In other areas I blend the charcoal in with my fingers. Finally I draw some parts more boldly with a thin stick of charcoal. If any part of the painting is unsatisfactory, charcoal can be re-applied and re-worked with the eraser.

This treatment results in a combination of strong drawing and broken areas of charcoal, through which the watercolour washes are just visible, and clear areas of watercolour where the charcoal has been entirely removed. For *The Kitchen Table* I have chosen my colours so that the pot and apples are warm in colour but within a general background of cool colours.

Charcoal and watercolour used together are ideal for making spontaneous impressions such as this. The result is a sketch rather than a polished painting.

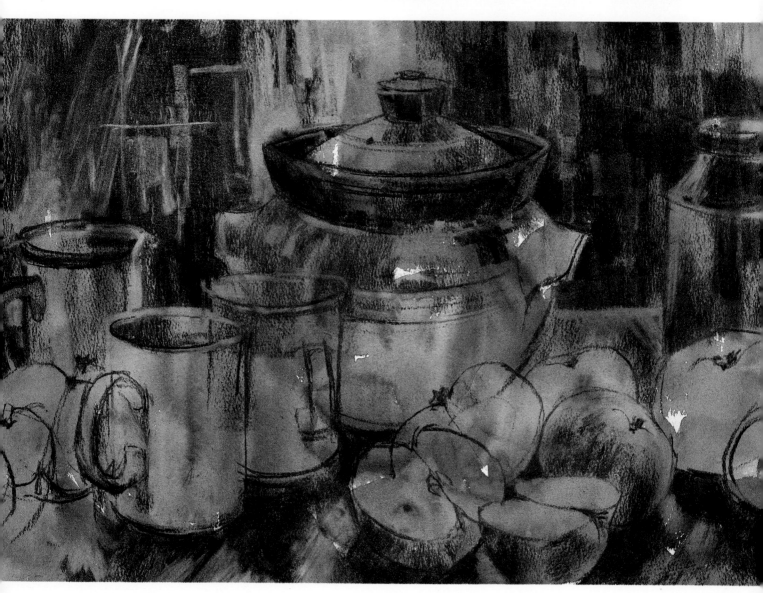

Charcoal over watercolour: *The Kitchen Table*

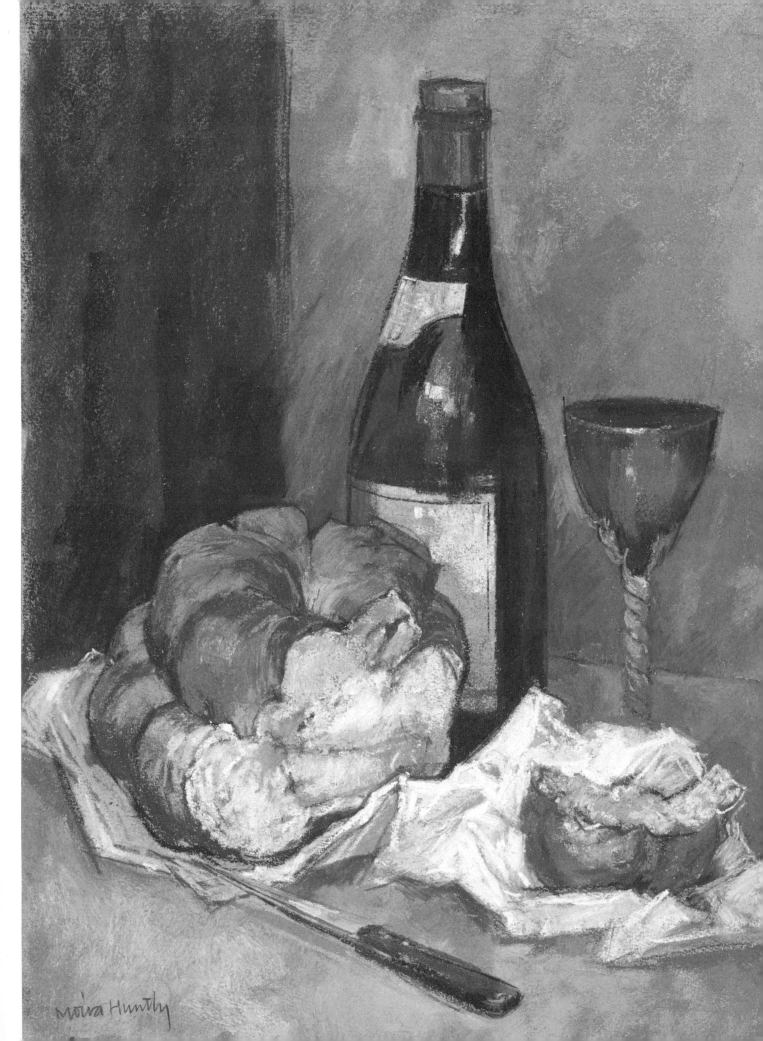

Moira Huntly

Pastel

Few people realise that pastel is a very permanent medium, even more so than oil paint. It is made with the same pigment but has no oil in it, so there are no drying or cracking problems. One great advantage of pastel is that a pastel painting can be left for some time unfinished and then continued without there being any need to re-mix colours. The same sticks of pastel are ready and waiting.

Many great artists of the past, such as La Tour, Chardin, Redon and Degas, used pastel. It is very versatile as it can be used for drawing or painting and enables a variety of textural effects to be obtained.

In the pastel painting opposite, *Bread and Wine*, I was particularly interested in the contrast between the smooth surfaces of the bottle and the wine glass, and the rough texture of the bread and the crumpled tissue paper. The smooth surfaces were obtained by pressing the side of a piece of pastel hard on to the paper and dragging it sideways. The rough surfaces were also produced by dragging the pastel sideways but with only a very light pressure that allowed the paper to show through the layer of pastel. Highlights were made by drawing with the tip of the pastel.

(opposite) **Pastel:** *Bread and Wine*

Pastel colours

There are many colours available and every colour has a range of six to eight tones, from very light to dark. Manufacturers have individual ways of numbering pastel sticks: in the UK, for example, Rowney's pastels are marked from tint 0 for the lightest to tint 8 for the darkest; in the USA, Grumbacher number their pastels from dark to light. In my demonstrations I have given the Rowney system.

I illustrate below six tones of olive green and six tones of cool grey on white Ingres paper, and again on green-grey paper. Notice how the tone of each pastel that is nearest to the tone of the coloured paper tends to disappear. And the colour as well as the tone of the paper affects the appearance of the pastel.

Because each colour has several tones there is an enormous number of

pastels to choose from and it is at first difficult to know what to buy. I started by buying 1 light, 1 medium and 1 dark tone of each colour, choosing olive green, cool grey and burnt umber, plus a few individual bright colours and a creamy white – and added others gradually. If you plan to do a lot of pastel painting, especially of flowers, you will need a greater range of pastels.

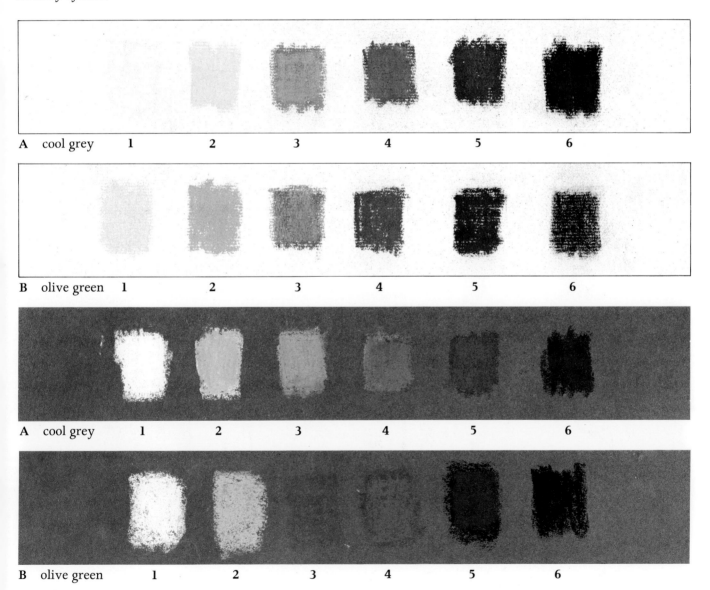

A cool grey 1 2 3 4 5 6

B olive green 1 2 3 4 5 6

A cool grey 1 2 3 4 5 6

B olive green 1 2 3 4 5 6

Conté pastel pencils

Pastel in a pencil form, which has been treated so that it is hard enough to be sharpened to a fine point. Useful for detail and large numbers of colours are available.

Paper

Ingres paper, watercolour paper, canvas, glass-paper. All these surfaces have a texture or tooth which is necessary to 'hold' the pastel. Ingres paper can be obtained in different weights and degrees of texture. It is usual to use a coloured support, the colour being allowed to show through the pastel and become part of the painting. You can prepare your own coloured backgrounds with washes of watercolour or thin gouache.

Putty eraser

A soft kneadable form of eraser which will lift off mistakes.

Fixative

Can be obtained in an aerosol can, or bottle (for use with a mouth diffuser).

A Tip

D Crosshatching

B Light pressure (side)

E Blending

C Heavy pressure (side)

F Long edge

Techniques

Pastel can be employed as a drawing medium or a painting medium: the tip being used for drawing and pieces of varying length being used on the long side for colouring areas. Pastel can be blended with the fingers or with a special stub. Personally I do not like rubbed pastel paintings because they look overworked and it is difficult to make a rubbed area look fresh again – I like pastel to look spontaneous and full of sparkle.

When I sit down to pastel, I put an old cloth on my knee to catch any loose pieces and I keep handy a strip of the paper that I am using, so that I can test the colour or tone of the pastel before applying it to the painting.

If there are to be several layers of pastel, it is advisable to fix the first layer. Do not try to build up too many layers because the pastel will not be able to adhere to the tooth of the paper and will drop off.

Mistakes can be rectified by lifting off pastel with a soft putty eraser, or by removing it with a stiff hog hair brush, or by carefully scraping it off with a razor blade if layers are thick. In the last case, care must be taken not to cut the paper or to spoil the surface.

When work is finished, give the paper a tap from behind to dislodge any loose pastel and then give it a light spray of fixative. When framing pastels, make sure that they have a deep enough mount to keep them from touching the glass.

So that pieces of pastel do not rub against each other and get too dirty when not in use, I keep similar colours together in little boxes or compartments. I put all the light blues and greys together, pale pinks and pale oranges together, mid-tone greens etc.

Oil pastels

These pastels are completely different from the soft pastels. They are greasy and so cannot be erased once applied. So start drawing with a light touch and then you can work over the top. It is possible to apply several layers without making the painting look dull or overworked. Oil pastels can be used on any white or coloured drawing paper and on canvas.

These pastels are available in only a limited range of bright colours but they can be mixed. This can be done optically on the paper by placing colours closely side by side or, alternatively, dots of colour can be superimposed and then blended together by rubbing.

Oil pastels can also be blended by applying a thin layer to the support and working into it with a brush dipped in turpentine. The resulting wash dries quickly and more pastel can be applied on top. Several layers can be built up in this way, and textures can be created by scratching the surface or by scraping away an area of the pastel.

An advantage of oil pastels is that they are easier to handle when sketching outdoors than the soft pastels which can be easily smudged. They can also be used for the preparatory sketches of oil paintings.

DEMONSTRATION IN PASTEL:
Fishes and Lemons

Materials

Canson Ingres paper, rust-coloured.
Pastels: blue grey tint 6, poppy red
 tint 8, cool grey tint 2, cool grey
 tint 4, warm grey tint 3, olive
 green tint 3, lemon yellow tint 2,
 burnt umber tint 8, warm white.
Fixative spray.

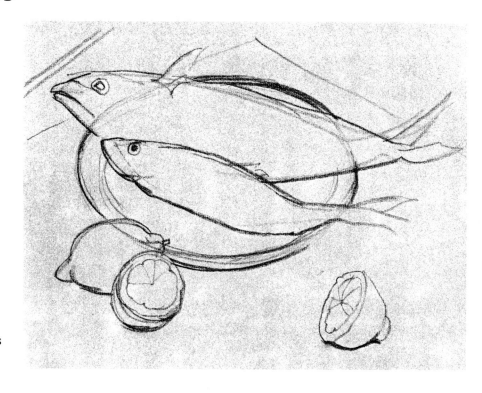

STAGE 1

In this painting I used very few
colours. It is a good idea, especially
at first, to limit strictly the number
of colours used. The medium is not
easy and a good pastel demands
freshness and spontaneity.

I draw in carefully the simple shapes
of the lemons, the fishes and the
plate. Although I can see only part
of the plate, I lightly indicate the
whole of it as though the fishes were
not there, so that the oval is
correctly drawn.

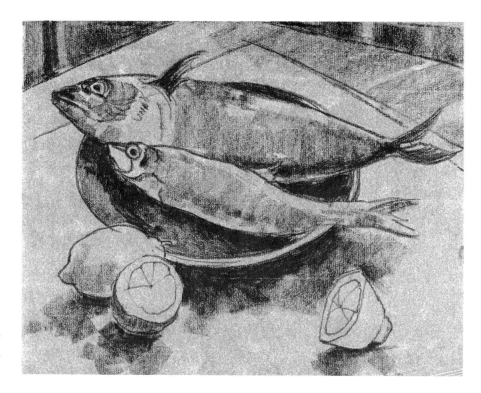

STAGE 2

I fill in the dark areas with dark
brown pastel (burnt umber no. 8),
sometimes using the side of the stick
which masses in large areas more
readily. Because it is so easy to
smudge pastel with hands or sleeves,
I use a fixative spray on the drawing
at this stage.

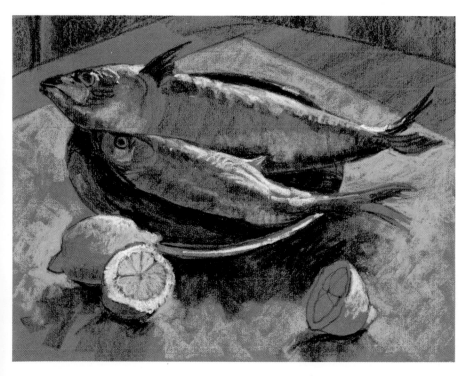

STAGE 3

Using cool grey no. 2, I start lightly to mass in the light areas. Some white pastel adds highlights to the top of the fishes and the lemons – but I blend some lemon yellow with the white on the cut face of the lemons and on the top of the lemons.

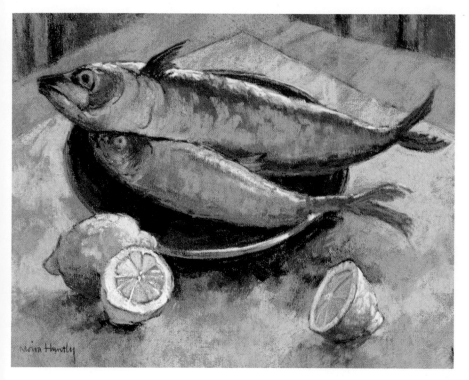

STAGE 4

Areas of mid-tone on the fishes and background are massed in with cool grey no. 4 and the warm grey. As I draw with more pressure, I leave little touches of the background paper showing through. This gives a feeling of warmth to a rather cold subject, and I find the effect very pleasing.

At this point it is a personal choice how detailed to make the painting. I add a little olive green to the shadow on the lemon skins and blend in some blue grey on parts of the fishes and background, finally adding a touch of red round the eye of the herring.

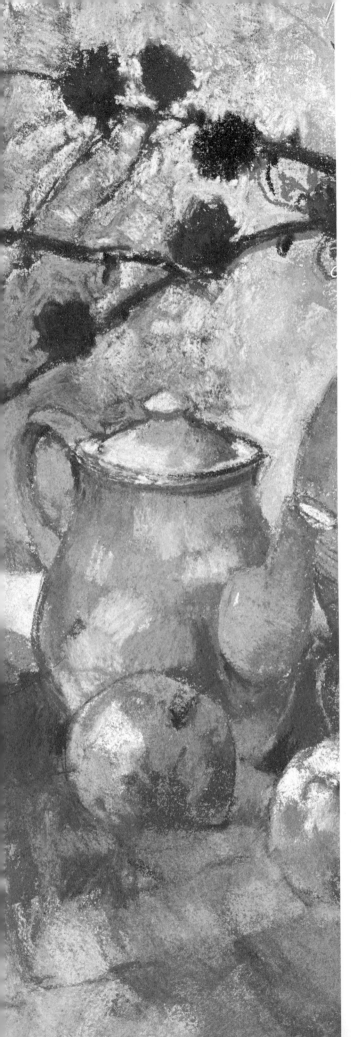

Pastel painting:
Larch Branches and Teapot

I began this pastel painting by drawing the subject with light brown Conté pastel pencil on pale stone-coloured Fabriano Ingres paper. I kept all the lines light until I was satisfied with the drawing, and then I drew the important parts of the composition more boldly with a darker Conté pastel pencil.

Following my usual tendency, I started to apply pastel at the top of the paper to reduce the risk of smudging it with my hand or sleeve. I used three light tones of raw umber, applying them with the side of the pastels in random directions. I then superimposed strokes of warm grey and pink. I used only light pressure so that the underneath colours broke through to give subtle colour and tonal changes.

The jug was incised with shallow rings round its body, but I had no wish to emphasise these in my painting, so I merely suggested them by dragging the pastel sideways following the roundness of the jug. The small vase was made to appear in front of the jug by the strong drawing of its ornamentation and the strong light contrast on its rim.

The teapot was treated in another way. This was because it reflected a number of different blue tints – pale and dark blue, blue-green and a hint of mauve. I applied these colours by pressing eash pastel on to the paper and dragging it sideways in short strokes. Pastel was applied to the apples and the cloth in a similar way.

This process followed a carefully thought-out plan. The blue teapot, the cloth and the apples were closely related in colour and in treatment so that they formed a unity. Similarly, I used the same pink for the background and on the small vase – and applied the pastel in such a way as to suggest broken light on both. The big jug was treated simply so that it became almost neutral within the group.

Then I added the last touches – the blue-grey shadow of the jug and its handle echoed the blue-grey mid-tone of the cloth and the larch branches made a strong dark drawing against the pale background.

The detail on this page shows the build-up of flat slabs of pigment in different directions. The particles can catch the light and give prominence to the teapot and the apples, whereas the background has a softer treatment and colour. The use of several different blues on the teapot gives a certain vibrancy to the painting. The greens on the apples have a similar effect.

(left) Full-size detail from (opposite) Pastel: *Larch Branches and Teapot*

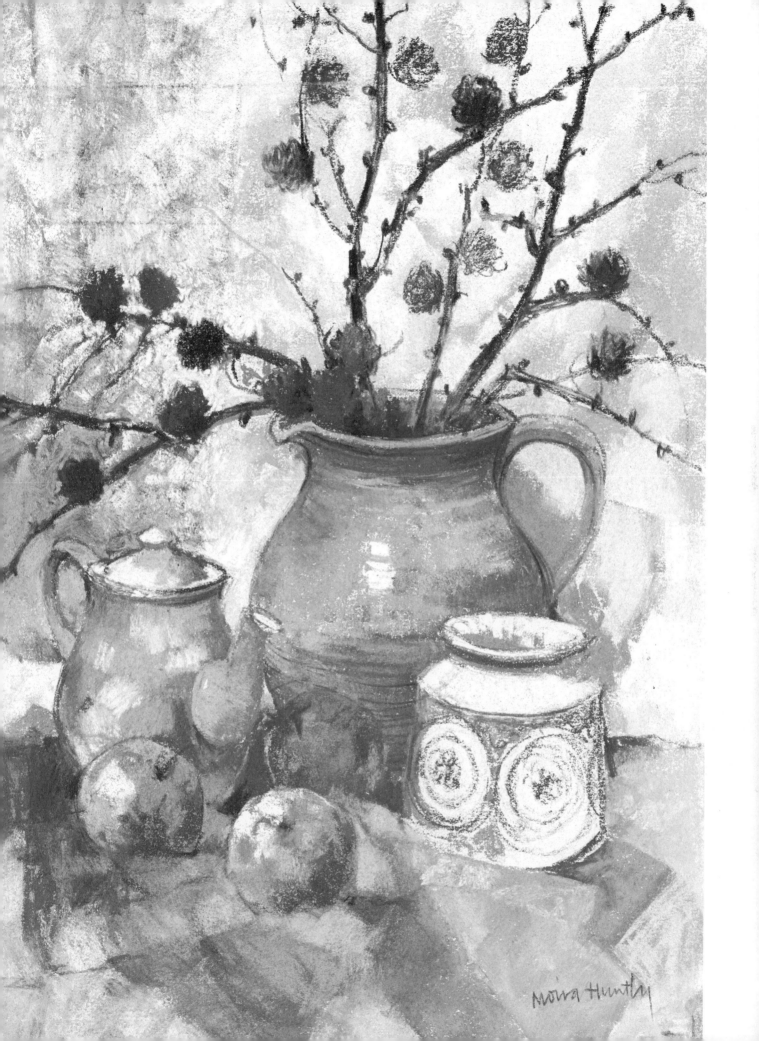

Moira Huntly

Pastel painting: *Flowers*

This pastel painting was painted on Canson Ingres paper. I prepared the paper by stretching it on a piece of plywood so that I could give it an undercoat of paint on which to apply the pastel (for stretching, see page 109). The paper was of a fawn colour and I brushed brown and green acrylic paint over it. (Acrylic paint has the advantage of drying quickly. See page 145.) The paint was applied vigorously with a 1″ household paintbrush in random directions and in parts I left paper showing. The purpose of the paint was to provide a background of broken colour, green and brown paint and fawn paper. I was not particularly concerned with painting flower shapes at this stage, but I was conscious that some of the brush strokes could suggest background leaves in the final painting.

I started to paint the flowers with direct strokes of pastel on its side, dragging it over the paper so that the undercoat of dark acrylic broke through to give the pastel a vibrant effect.

Notice that I did not draw each petal outline. I thought more in terms of painting and I used strokes of pastel, in varying lengths and in dots and flicks. In this way the pastel clings to the texture of the paper surface so that it sparkles and glints in the light.

For the phlox I used red purple in tints 1, 3 and 6 and pansy violet tint 1 for the very bright petals. The daisies were purple grey tint 2, with coeruleum tint 0 for the highlights.

I did not use white for the daisies because it would have looked too stark and contrasty. In any case, daisies in nature reflect surrounding colours, the white becoming tinged with other colours.

The montbretia was painted in cadmium orange tints 1 and 4 and burnt umber tint 6.

I built up the picture gradually, not concentrating on any one part. I painted a little of one flower, then another, and I introduced a little colour into the background.

I sought to convey an impression of light on the flowers and had no wish to paint a formal arrangement. Nevertheless it is always important to emphasise slightly one part of the picture. So I chose the phlox in the top right of the group and the upper daisies. As the painting developed I placed the emphasis by pressing the pastel strokes harder on the paper.

The impression of light on the flowers was enhanced by the relatively muted and darker colours of the background. I used raw umber tints 2 and 5, green grey tints 1, 5 and 6 and terre verte tint 5. I left uncovered some of the acrylic wash beneath the painting.

This detail from the finished painting shows a variety of pastel strokes, some dragged lightly and some pressed hard on to the paper.

(left) Full-size detail from (opposite) **Pastel and acrylic:** *Flowers*

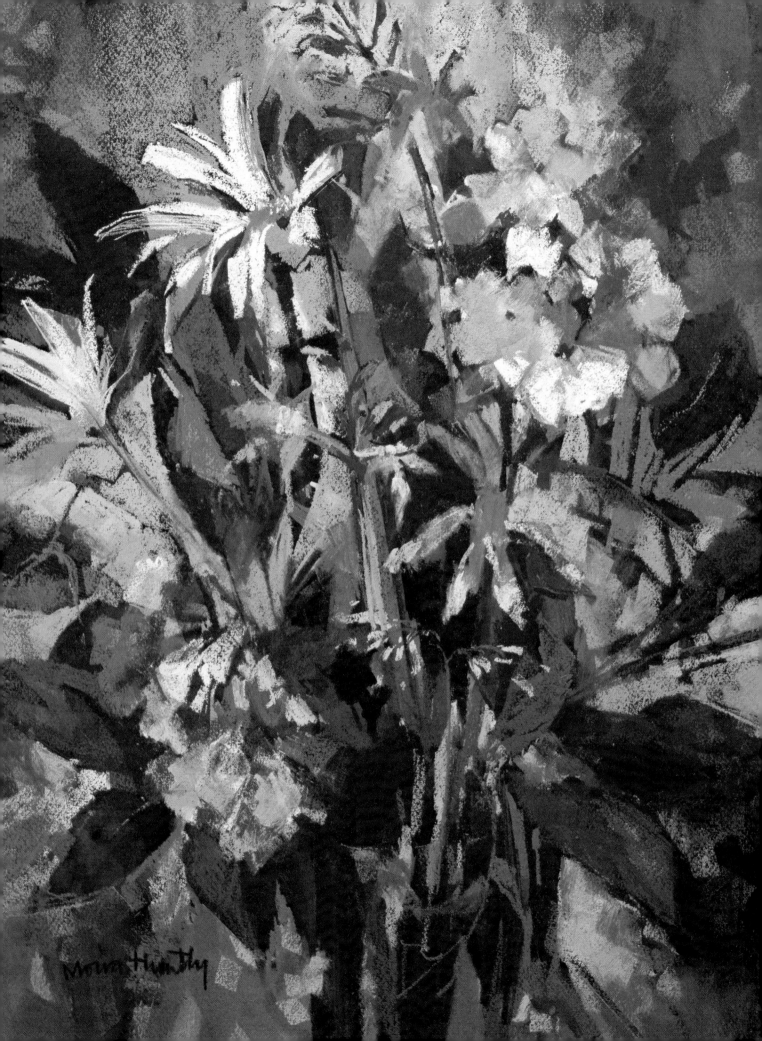

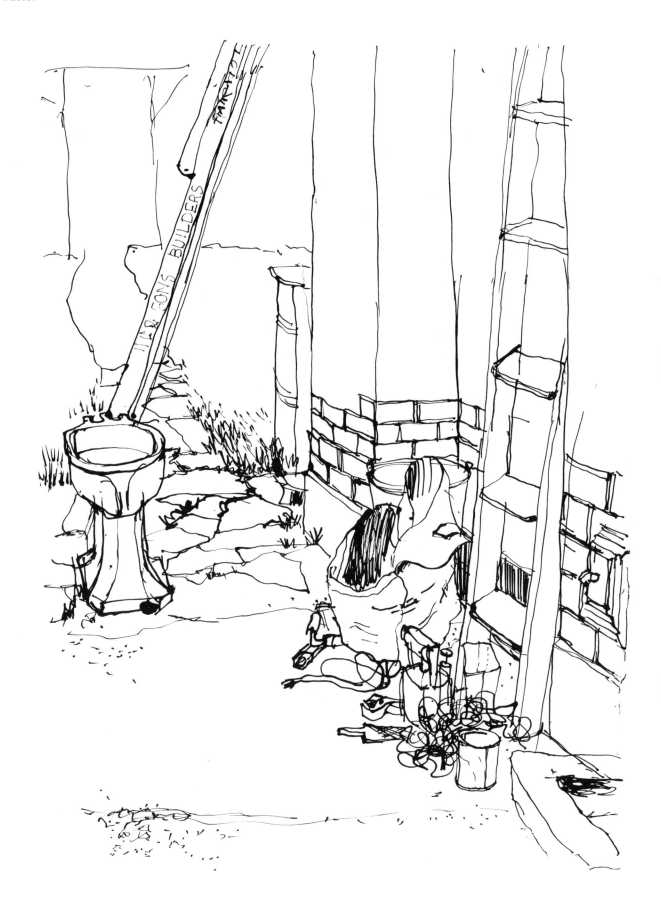

DEMONSTRATION IN PASTEL AND INK:
The Back Yard

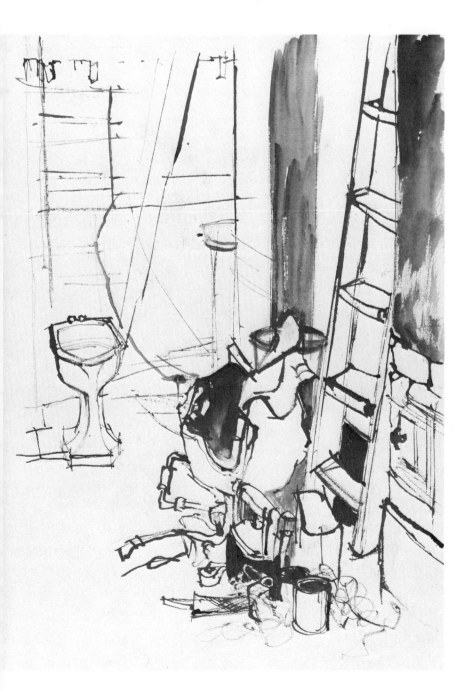

I made this demonstration painting from a sketch that I drew as a young student. It was in an old sketchbook that I had kept – which shows how useful and interesting it is to hold on to old sketchbooks!

Materials

Canson Ingres paper, fawn-coloured.
Black Indian ink.
Watercolour: burnt sienna.
Pastels: green grey tints 1 and 4, cool grey tint 5, blue grey tint 4, terre verte tints 1 and 8, cobalt tint 0, burnt umber tint 2, yellow ochre tint 1.

STAGE 1

I draw the subject in black Indian ink on a piece of fawn paper: the very fine lines are drawn with a pen and the thicker lines with a piece of sharpened twig taken from a bush in the garden. Even though I know that much of the drawing will be covered with pastel, I still think in terms of thin lines and thick broken lines. In some areas I brush in some ink and in others ink diluted with water.

I make the drawing with the intention of directing the eye towards the top left-hand corner: in fact, the ladder, the kettle handle and all my preliminary construction lines are drawn pointing in that direction.

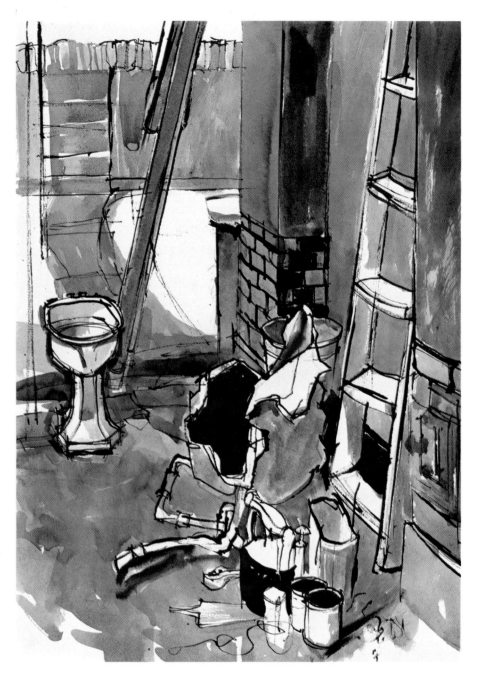

STAGE 3

I choose a few pastels and work selectively over the drawing so that I make the light pastels really sing: a pale blue cobalt tint 0 with hints of grey green tint 1 for the ladder on the right, and a darker blue grey tint 4 for the shaded side of the ladder. For the ground shadow I use a mixture of blue grey tint 4 and cool grey tint 5. I have to be careful not to overdo the light pastel in the area of the ladder because I want to concentrate the main lights in the top corner. This calls for certain discipline and judgment.

Finally, using burnt umber tint 2 and yellow ochre tint 1, I concentrate on the piece of wall in the background that catches the bright sunlight. I press the pastel hard on to the paper and drag it sideways with quick short strokes. I use the pale green grey tint 1 and terre verte tint 1 with hints of the previously used blue cobalt tint 0 and green grey tint 1. It is interesting that some of these same colours are used in both the light and the shadowed areas. This succeeds because the sunlit wall is one big area of light pastel, whereas elsewhere the pastel is limited to the highlights within an area of shade. On other light areas of the ground I add touches of yellow ochre tint 1 and deepen the foreground shadows with terre verte tint 8. Much of this painting is of cool greens and blue greys on a warm ground.

STAGE 2

I reinforce the drawing with a few more thin and thick ink lines and wash a few more areas with diluted black ink. Then I wash burnt sienna watercolour over the drawing, leaving the paper showing for the highlights. This use of watercolour can make the paper cockle so that it is advisable to stretch it and leave it to dry before putting on any pastel. (How to stretch paper is described in the chapter on watercolour – see page 109.)

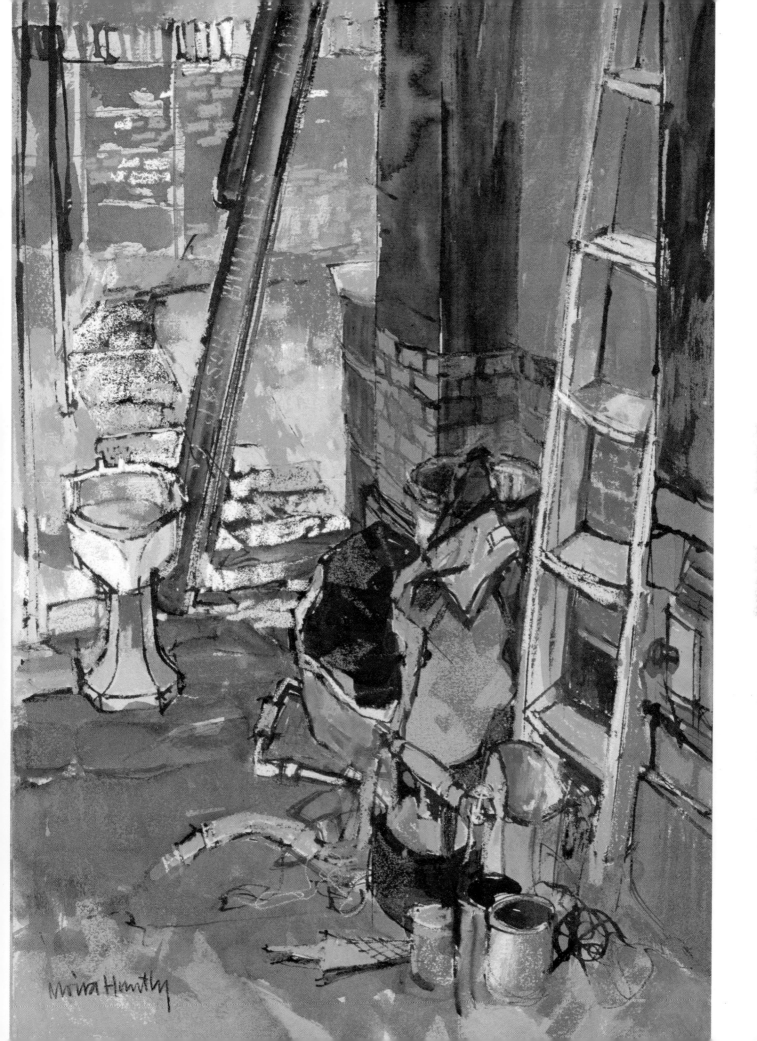

Roller patterns

Here are various marks made with the printing roller, some heavily inked, some unevenly inked, some made when the roller is twisted while in use, and some made when the roller is getting dry.

Pastel over printing ink:
Bottles and Fruit I and II

These last two paintings in pastel were started accidentally. Both were painted in pastel on top of printed ink. I had been using a rubber roller to apply ink when printing a lino-cut. I cleaned the roller by rolling it in random directions on a piece of paper and noticed that this made interesting patterns. I decided to experiment with these marks and to use them as a basis for a pastel painting.

Visual impressions, such as natural or man-made pattern or texture, can be the starting point for the interpretation of a subject not yet decided upon. I think this is a valid way of working – pattern or texture leading to a subject rather than the other way round.

In my two paintings overleaf of bottles and fruit, I made use of an image created by random movements of the roller and made intentional adjustments with pastel. The circular marks were made with a cork, pressed on to the roller's inking slab and then on to the paper. These marks came to represent fruit or bottle labels in the painting. Textures other than cork could be used to different effect, e.g. string, rough fabrics or short stiff brushes.

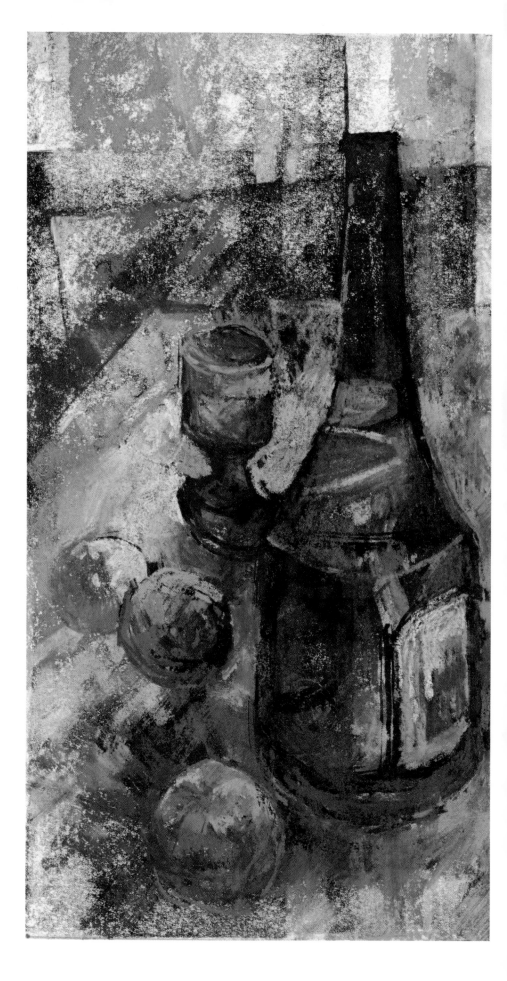

(right) **Pastel and printing ink:**
Bottles and Fruit I **(far right)** *II*

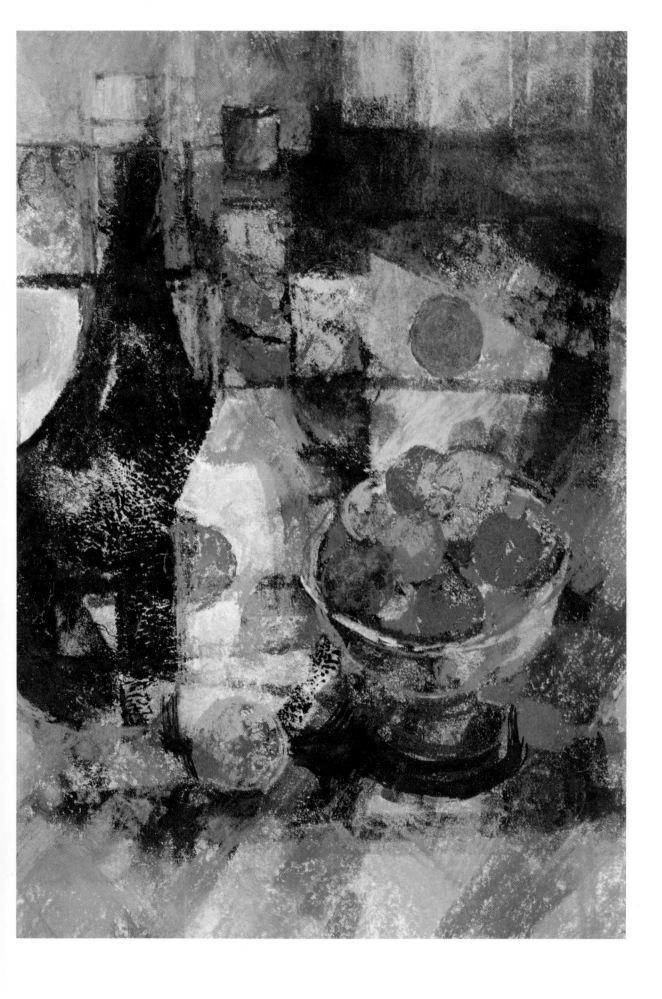

Line and wash: *Street Market Baskets*

Ink and Mixed Media

There have already been a few examples of combining one medium with another. The scope for experiment is endless and exciting. In this chapter I can describe only a few combinations and techniques. But many variations are possible: watercolour and wax; ink and wax; watercolour and pastel; ink, oil pastel and turpentine; charcoal and thin oil paint; pastel and oil paint; gouache, ink and wax; coloured pencil and ink.

There are various 'resist' materials that lead to interesting line and textural effects when they are painted over with ink: candle wax, masking fluid, Copydex and wax crayons.

The Cubist painters used many such combinations on a variety of backgrounds to very interesting effect: for example, charcoal and oil paint on canvas; pencil, oil paint, charcoal, coloured paper and newspaper on canvas; gouache and watercolour on paper.

For me, the purpose of experimenting with various materials and techniques is to discover what effects they all have on each other and what impression they make on the eye when in combination. It is a kind of research that enables me to create textures, patterns, movement or atmosphere in a painting which might not be possible by conventional means.

I then have a greater number of answers when I ask myself questions about the kind of line or mark which I want to make. Do I want a smooth flowing line or a thin jagged or broken line? Which tool, material or technique is best suited to the line I want? Do I want a rough texture or a soft-edged spreading effect such as can be obtained if I work on a wet surface? If the final result is satisfying to the artist, then surely it is valid however conventional or unconventional the means.

In my painting opposite, called *Street Market Baskets*, loose watercolour washes of Payne's grey and raw sienna were applied first. When they were dry, the baskets of fruit were drawn in with a Gillot 303 pen and Indian ink. This picture is reproduced the same size as the original so as to show exactly the variation of line thickness; some lines very fine and sensitive, others strong and dark.

Materials

Pens

These can vary as much as pencils. The old-fashioned school nib is good to draw with but not always obtainable nowadays. Mapping pens are suitable only for delicate detail and minute cross-hatching, whereas artists' dip pens allow a more varied line, according to the angle at which they are held and the pressure exerted. Reed, bamboo and quill pens are good for bold lines. The nib can be cut narrower or wider with a sharp knife or razor blade. All these pens have to be dipped frequently in the ink.

Special pens, such as Rapidograph and Rotring, control the flow of ink by means of a needle valve in the fine tube that forms the nib. Nibs are available in several sizes and are interchangeable. The line they produce is of even thickness, but they have to be held at a right-angle to the paper, which is a disadvantage.

Sticks

Pieces of ordinary stick can produce a variety of different lines. The wood quickly absorbs some of the ink, which gives a dry quality to the drawing.

Inks

Only black and white waterproof inks are guaranteed permanent, while all coloured inks are fugitive. If waterproof Indian ink has to be thinned, use distilled water or rain water, as ordinary tap water will cause it to curdle.

Brushes

These make versatile drawing instruments. The biggest sable brush has a fine point and the smallest brush laid on its side provides a line broader than the broadest nib. Wash the ink out immediately after use with clean water.

Paper

Bristol Board for fine pen work. Ingres paper, watercolour paper and heavy cartridge paper will take ink, wash and pastel. It is advisable to stretch the paper in advance if watercolour washes are to be used. (See page 109.)

Other materials for mixed media paintings will be mentioned as required.

1

2

3

Techniques

The thought of drawing in ink can be intimidating to a beginner simply because of the knowledge that mistakes cannot be erased. Talk yourself out of this fear – all drawing is exploratory, mistakes are part of the learning process and they can often be absorbed into the drawing as work progresses. As with everything else, the more often you draw with ink the more confident you will become.

Ink drawing does not have to be always on dry paper. The three 'doodles' reproduced here show some of the interesting effects achieved by using ink on a damp surface. The blots (1) came from dropping Indian ink from a brush on to flat watercolour paper that was dampened with clean water. 2 shows diluted ink brushed on to damp paper, with pen and ink lines drawn as the paper dried. The lines are fuzzy where the paper is still quite damp, more precise where it is drier. 3 shows drawing on damp paper with a stick dipped in Indian ink. The line in the centre was drawn first and the ink immediately spread into the damp paper with a pleasing pale grey diffused effect. The surrounding lines were drawn with the stick as the paper dried.

The drawing opposite of shells employs most of these techniques: lines drawn with a stick, pen lines, some on to dry paper and some on to wet paper. Diluted ink is brushed over some areas of the drawing. The seaweed was painted with a brush and watercolour and then drawn on with a stick and waterproof ink.

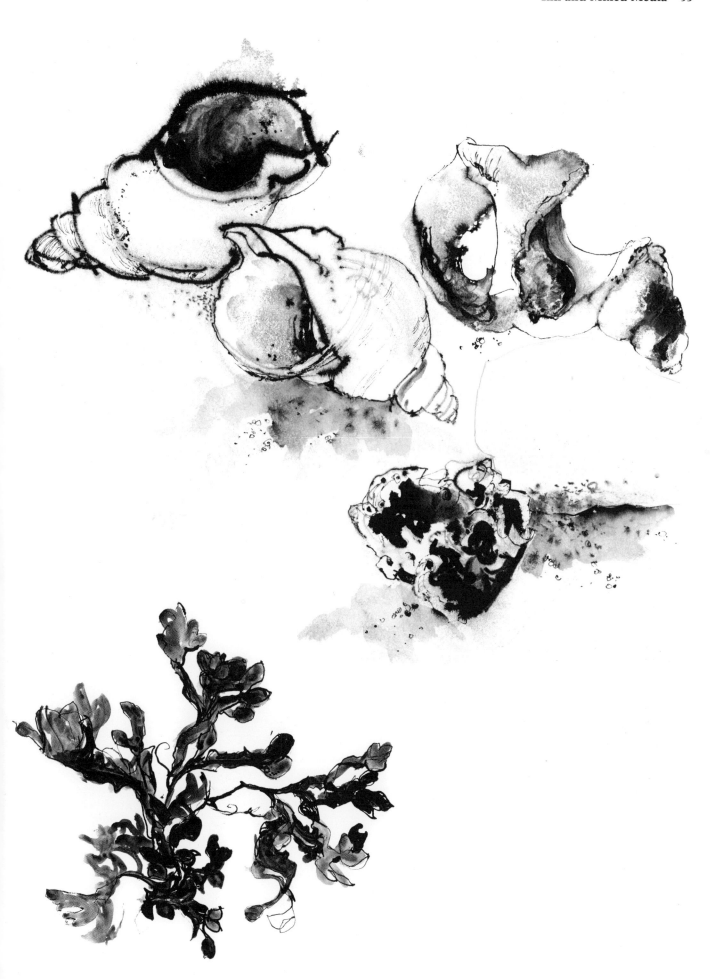

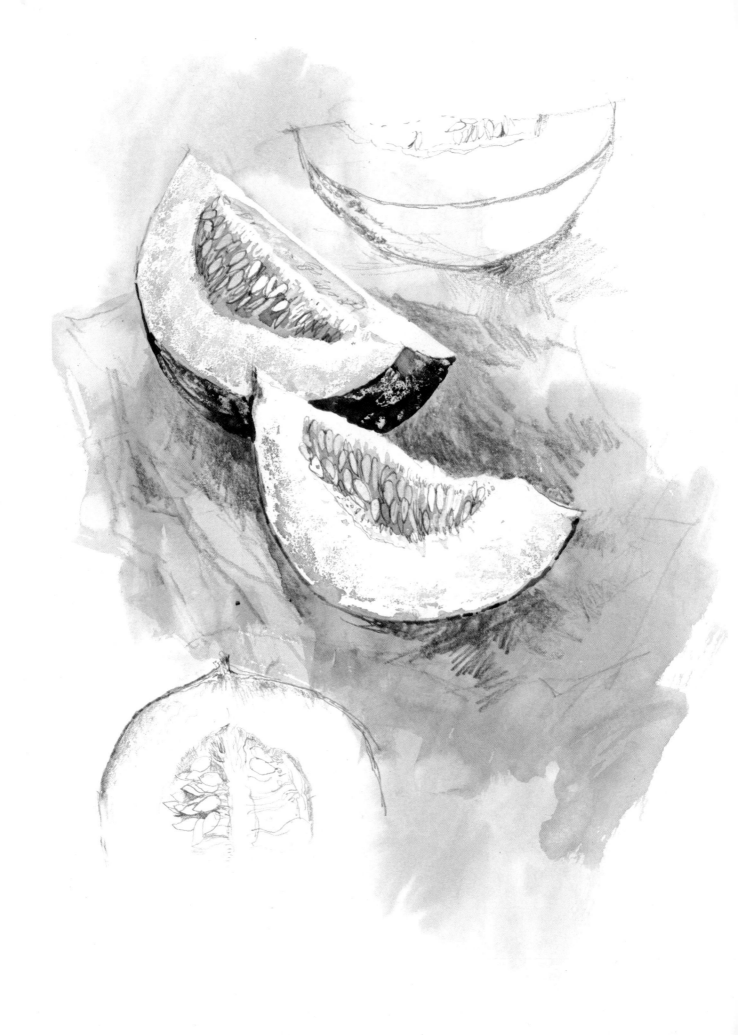

DEMONSTRATION IN PENCIL, MASKING FLUID AND WATERCOLOUR: *Melons*

This demonstration combines the precision of pencil drawing and of masking fluid with the softness of freely applied watercolour washes.

Materials

Heavy cartridge paper.
2B pencil.
Squirrel hair brush no. 12.
Masking fluid.
Watercolours: Payne's grey, burnt
 sienna.

Masking fluid is a rubber solution which can be applied to paper with a brush or pen. Once dry it is useful for keeping an area of the painting untouched by the watercolour wash. When the wash is dry, the masking fluid is rubbed away with the finger tip to expose the original surface. Masking fluid should never be dried in the sun, as the sunlight causes its properties to change and it then becomes difficult to rub away. Use a nylon or an old brush for the fluid, washing it out immediately after use with clean water.

STAGE 1 (not illustrated)

I draw the melons with a soft 2B pencil and use the side of the lead to block in the shadows. I sharpen the pencil to a fine point before drawing in the melon seeds.

STAGE 2

I cover the cut sides and a few of the seeds with masking fluid and allow this to dry completely.

STAGE 3

I gently rub away the masking fluid from some areas of the cut sides before applying the first wash. I use a very large brush to cover the paper completely with a very dilute wash of Payne's grey. While it is still wet I strengthen the wash in places with more Payne's grey and introduce a little burnt sienna on the cut faces of the melon. This appears as a broken texture where I have partly rubbed away the masking fluid.

When this wash has dried I paint some of the melon seeds with masking fluid and cover them with a strong wash of burnt sienna. When this, too, has dried, the masking fluid is rubbed away to expose some white seeds and some grey seeds and a broken texture on the sides of the melon.

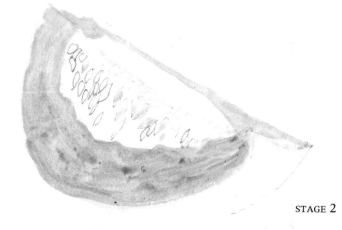

STAGE 2

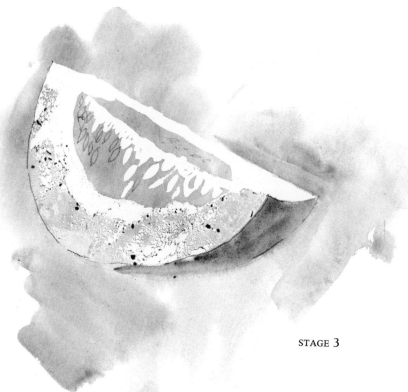

STAGE 3

Moira Huntly

Ink, watercolour and pastel:
Boats at Polperro, Cornwall

The mixed media painting reproduced on the previous spread employs the more popular mixture of ink and wash with some additional touches of pastel. I use black Indian ink because it is permanent.

Boats lying high and dry while the tide is out make good still life subjects. The boats at Polperro were painted from a window one wet afternoon. I liked the pattern of darks and lights and the masts cutting across the painting at an angle.

There was no preliminary drawing, I went straight ahead. I used a $1\frac{1}{2}''$ house painter's brush to cover the paper with raw umber and burnt sienna watercolour, applying the watercolour in broad random strokes with no attempt to produce a flat, even surface – but I left some white paper showing for the boats. I then used a piece of stick and some Indian ink and rapidly drew in the outlines of the boats. In places the watercolour was still wet and the ink ran into it, giving a diffused effect to the lines.

Using a medium sized round sable brush, I finished the painting with a few brush strokes of burnt umber, pale yellow and pale blue on the boats, and with a hint of pastel here and there.

(pages 98–99) Ink, watercolour and pastel: *Boats at Polperro, Cornwall*

Abstract shapes

The two diagrams based on details from the painting illustrate how I picked out abstract shapes. Each little piece is a pattern in itself and yet it is a part of the whole. We have to look at shapes as we paint and often subconsciously repeat a shape. This gives a unity as well as a rhythm to a painting. In this case, the entire painting consists of abstract shapes.

A The shapes of the sterns of the small boats are almost identical but the angles vary enough to add interest. In placing the boats I was also concerned with making the ground an interesting shape.

B The white mast cuts across the stern of the big boat in such a way that the dark stern is more interesting visually than cutting one shape into two equal and symmetrical shapes.

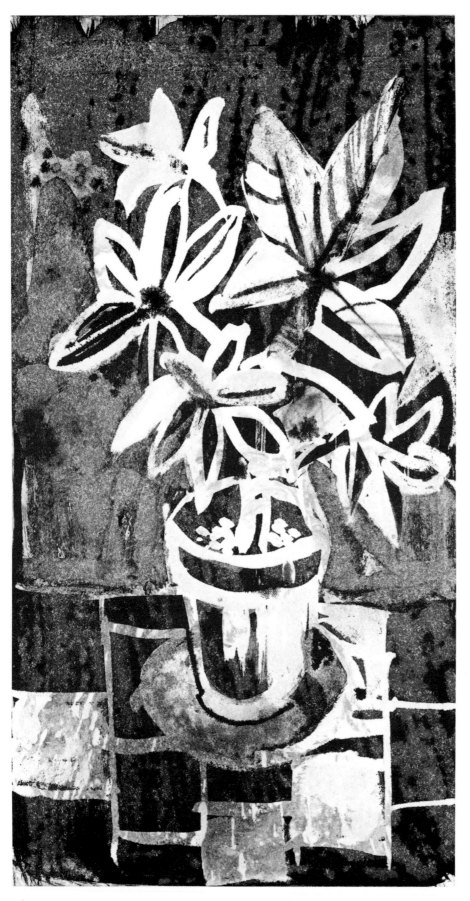

Ink and poster colour techniques

The little diagrams show a method of using ink and white poster colour to achieve a monochrome painting with interesting graphic qualities.

Poster paint is water-based colour in a paste form ready for use. It has good covering properties and dries matt. It is ideal for this mixed media technique because the poster paint is thick and prevents ink from penetrating through it to the surface of the paper beneath. At the same time it is soluble in water so can be washed off under a tap at the end of the process.

1 Use thick paper or card. Paint all white areas and lines with thick white poster paint (tinted with watercolour so that it shows up against the white paper). Make a preliminary light pencil outline if you wish.

2 Allow the paint to dry.

3 Cover the whole sheet with waterproof black Indian ink, using a wide brush.

4 Leave this to dry.

5 Lay the paper in cold water, and the layer of ink lying on top of the poster paint will lift. The ink remains on the unpainted surface of the paper only.

6 Hold under running water and sponge or brush off the white paint.

Ink and poster colour: *Pot Plant*

Ink and poster colour:
The Studio

The still life painting of the easel and chairs (page 105) was produced by the technique just described. It is a way of working that makes you look at the spaces between objects as well as at the objects themselves. These 'in between' spaces are known as negative shapes and are just as important as the positive shapes for they are an integral part of a composition. This concentration on negative shapes is a disciplined exercise in observation.

I started work by painting the negative shapes with slightly tinted white poster paint so that I could see it against the thick white paper on which I was working. When it was dry, I covered the whole of the paper with Indian ink. When this was dry, I immersed the paper in cold water which loosened and washed away the areas of poster paint (and the ink on it), leaving black ink adhering to the unpainted white paper. So although I started by painting only negative shapes with white paint, I finished up with a painting which had black ink as the positive shapes.

It sounds a drastic process to go to the trouble of making a complicated drawing and then to cover it with black ink, but it is exciting to watch the ink shapes emerge under the tap. By choosing an easel and chairs as the subject, I could arrange them to make an interesting overlapping pattern of darks and lights that lent itself well to this particular treatment.

You will perhaps notice that the dark shapes in the painting are mottled here and there with grey. This occurs where the ink is not quite dry and is partially washed away, leaving these pale stains. There is also evidence of brush marks and textures within the painting – these were deliberately created by the use of a stiff brush on the areas originally painted with poster colour. The watercolour used for tinting the white poster paint leaves a faint stain on the paper which makes a pleasing background tint.

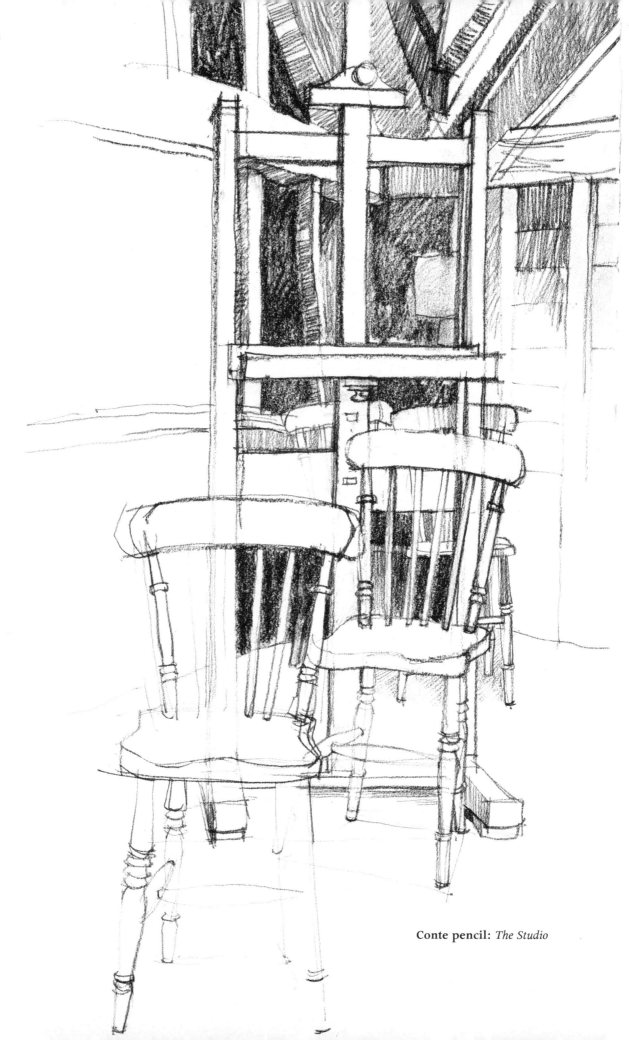

Conte pencil: *The Studio*

Ink and poster
colour: *The
Studio*

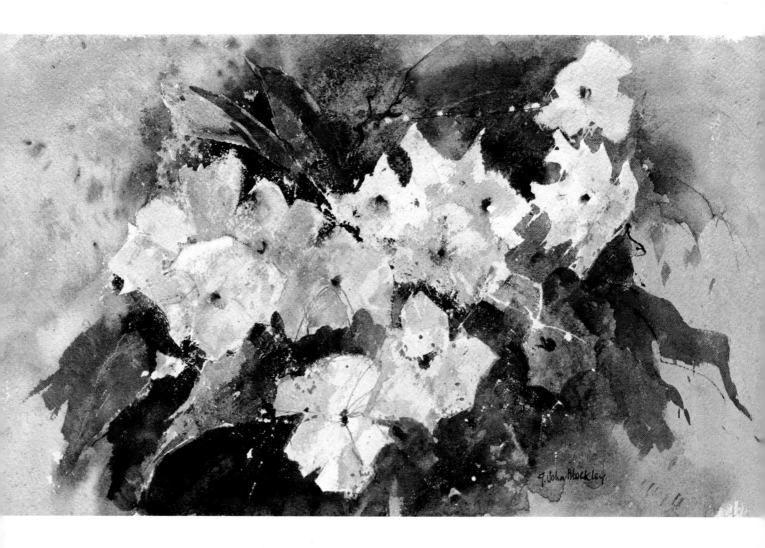

CHAPTER SEVEN

Watercolour and Gouache

Pure watercolour is one of the most exciting and, at the same time, most frustrating mediums. It dries differently each time, according to the atmosphere or the kind of paper or the amount of water on the brush. Each painting is an adventure with an unpredictable result. Just keep trying and when you do finally achieve what you feel is a successful painting, you will feel well rewarded for your efforts.

Dürer, in the fifteenth century, was one of the earliest European artists to use watercolour but before then it was extensively used by Chinese and Japanese artists – and by medieval illuminators. It was not until the eighteenth century, however, that watercolour painting reached a peak in England with such painters as Thomas Girtin, John Sell Cotman, Peter DeWint and John Crome.

In the same century, William Blake sometimes used a combination of watercolour and gouache, as did medieval illuminators before him.

Gouache, which is watercolour in an opaque form, was used by Van Dyck and Poussin in the seventeenth century and by many artists since. Flowers have always been popular subjects for still life painting. The watercolour (shown opposite) of cherry blossom was painted by the British watercolourist John Blockley. It is a very quick sketch, painted with assurance to record a cluster of blossom catching the light. The technique relies on a background wash of darker colour to surround and define the mass of light blossom within it. Individual flowers are suggested by just a few brush strokes and dots of pink within the mass and by the clever selection of hard-edged petals against the dark background.

The important point about this sketch is that it is a free impression of a mass of blossom and not a botanical study of individual flowers.

John Blockley:
Cherry Blossom (watercolour)

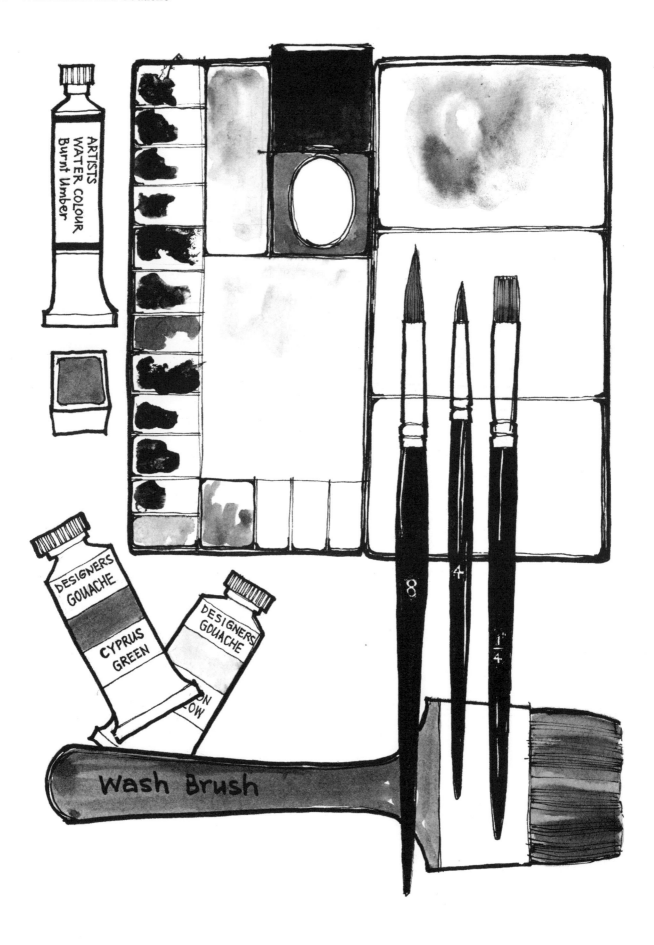

Materials

Paint

Transparent watercolour is pigment plus gum arabic, which can be diluted with water. It can be obtained in tubes or pans. It is worth buying the best artists' quality paints and saving money on other equipment such as palettes (which can be replaced by old white saucers). Put the tops firmly back on the tubes immediately after use to prevent the paint from drying up.

Gouache, or 'body colour', is an opaque watercolour. The colour pigment is ground in water and thickened with gum arabic – then white pigment is added to make the paint opaque. This means that gouache, unlike transparent watercolour, can be used for light areas over dark areas and on dark papers as well as light papers. Artists' or designers' gouache is a permanent medium, whereas poster or powder colour can fade. Keep the tubes of colour in a cool place and replace the caps immediately after use, for otherwise the paint will dry up. (See also page 112.)

Paper

Watercolour paper can be obtained in a variety of weights and surface qualities. Hand-made papers are usually very expensive, mould-made papers less so, but experiment will show which surface to favour and it will not necessarily be the most expensive paper.

Hot pressed smooth surface is best for drawings or line and wash.

'NOT' surface means *not* hot pressed. This paper has some texture and is good for wash and line work.

Rough papers are highly textured, good for washes and less detailed work.

Weights of paper
Thin paper (70–90 lbs: 180g/m²) requires stretching.
Medium (140 lbs: 285 g/m²) and Heavy (200 lbs: 410 g/m²) may require stretching if in a very large sheet or being worked very wet.
Extra Heavy (400 lbs: 820 g/m²) is more like board and requires no stretching.

Brushes

Watercolour brushes can be round or chisel shaped.

To keep brushes a long time, do not leave them standing in water. Rinse them thoroughly in clean water, shake them and gently re-shape them between fingers and thumb. Leave them to dry upright in a pot, bristles uppermost.

Sable Expensive, but the best. Try to own at least one good sable. Even the largest will come to a fine point and be very versatile. With care, it should last for years.

Ox, squirrel and camel hair All suitable and less expensive than sable but not such good quality.

Basic requirements
1 large brush (no. 10 or no. 12) for large washes (it is also possible to use a soft shaving brush or a small sponge).
1 medium brush (no. 5 or no. 6, round or chisel).
1 fine brush for detail (no. 0 or no. 1).

Other equipment

Large pots for plenty of clean water.
Tissues or sponge for 'lifting off' paint.
Brown gummed paper strip for stretching paper.

Stretching paper

Thin paper will always require stretching in order to avoid cockling when a wash is applied. A very large piece of paper, even of a heavier quality, will also require stretching, particularly for the wet-into-wet technique of painting (see page 116F).

How to stretch paper:

1 Use a strong clean wooden board larger than the piece of paper.
2 Soak the paper in a bath of clean water for a few minutes – longer if the paper is heavyweight.
3 Lift the paper carefully and let the water drip off.
4 Lay the paper on the board and gently dab away any excess water, especially at the edges of the paper, with a clean soft cloth or towel.
5 Fix the four sides of the paper to the board with gummed paper.
6 Leave flat to dry, without artificial heat and away from direct sunlight.

Gouache: *The Printing Press*

The pen drawing that I had made of an old printing press provided me with inspiration for the gouache painting opposite. The shapes were intricate and to begin with I had to look for the basic construction lines for both the drawing and the painting before adding the detail gradually.

With a gouache painting I like to start drawing the subject with a brush, then to use thin washes of semi-transparent paint and gradually to build up the thickness in much the same way as with an oil painting (see page 50).

The printing press was drawn on a piece of blue-green Ingres mount board with Prussian blue, which is a strong gouache colour. At this stage the top of the press was painted in as a solid dark shape with a flat $\frac{1}{2}''$ sable brush. The base of the press was then drawn in with a no. 6 round sable brush, some of the line work being firm and the rest of it 'dragged' with nearly dry paint.

I applied thicker gouache, using a pale mixture of raw sienna and white, over the upper parts of the press, leaving the blue undercoat to show through as the lettering. In places I dragged the gouache with a stiff brush over the board to let the blue break through.

The drawing was re-inforced with black Indian ink and a no. 2 sable brush, leaving much of the original broken line still visible in the final painting.

Using cypress green I painted the gaps between the machine parts, leaving some of the first underpaint to form interesting dark crisp shapes. The bed of the press was painted with raw sienna and umber to give a change of localised colour, and some olive green was introduced into the background.

This painting is a mixture of strong blocked-in shapes, with broken line work elsewhere acting as a contrast. It is composed of both thick and thin paint and makes use of the original paper colour, especially at the bottom of the painting.

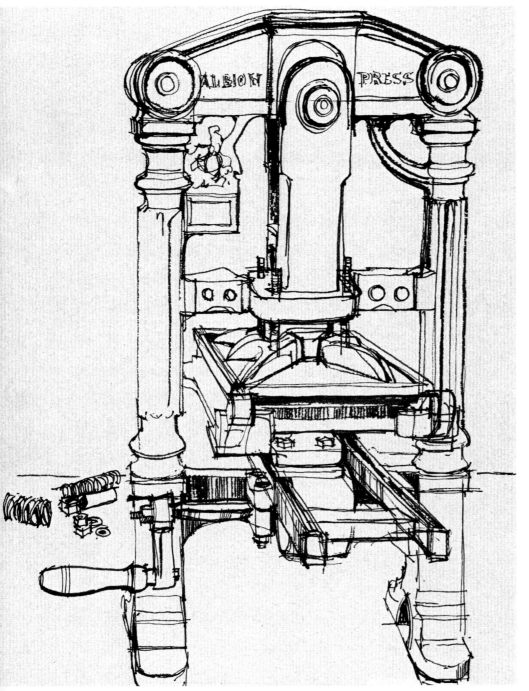

Fibre-tip pen on tinted paper:
The Printing Press
(opposite) Gouache on mountboard:
The Printing Press

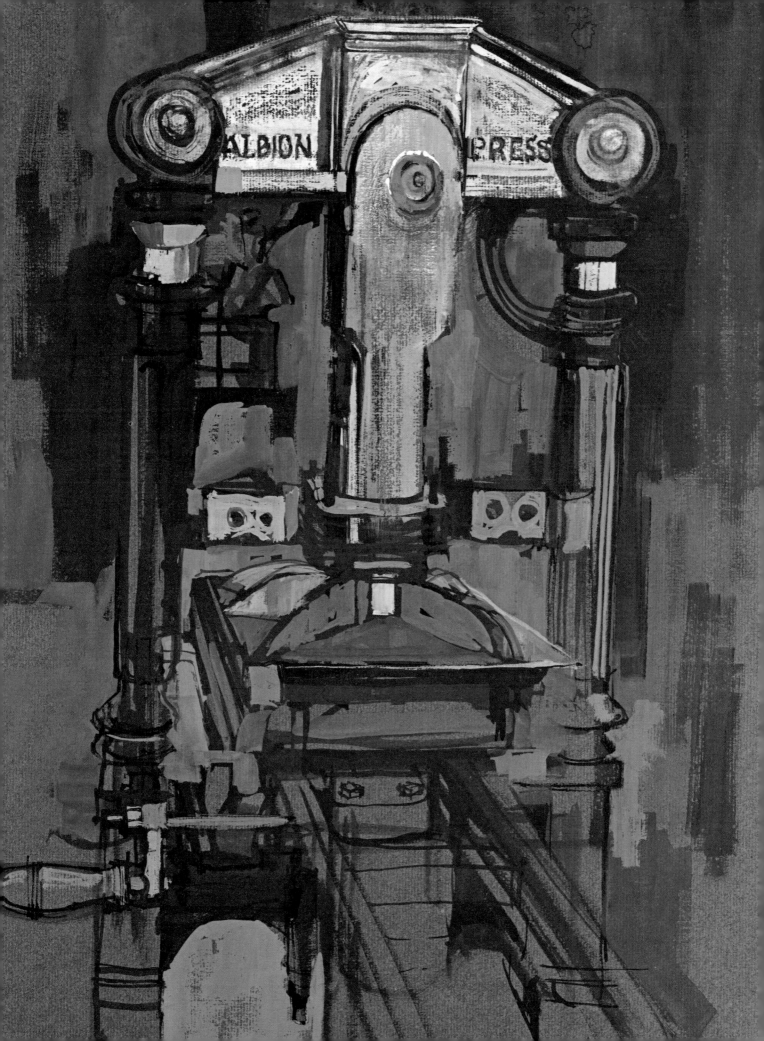

Painting in gouache

Gouache is good for painting out of doors as well as in the studio. It dries quickly, it can be used thick or thin and it can be applied wet-into-wet (see page 116F). However, paint that is too thickly applied will tend to crack and there is a limit to the amount of overpainting possible because gouache is soluble in water and will tend to lift off. It has a pastel-like quality when dry – be careful not to rub the surface of a gouache painting against anything as it can then become shiny.

The tone of a gouache colour can change as the paint dries – the more water that is used in the mixture the greater the change in the tone. If the paint is kept as dry as possible there is very little change.

Permanent white gouache can also be used with watercolour. Gouache colours tend to be very bright but a brushful of the less intense transparent watercolour added to white gouache will produce a more subtle colour. A great range of colours is made available by this means.

Brushes

Brushes can be the same as for watercolour. Bristle or hog hair brushes can be used for areas of thick paint or for dry brush effects.

Paper

A variety of surfaces is suitable for gouache, from the Ingres paper also used for pastels to any watercolour paper or mount board. Thin papers will need stretching as for watercolour (see page 109).

A

B

C

D

Gouache techniques

A Gouache diluted with water is brushed on to dampened white paper.

B Gouache painted on to dry paper and followed by brush strokes of black gouache applied before the first wash is quite dry.

C The opposite of B: brush strokes of white gouache over a dry wash, showing that opaque light colour can be painted over a dark colour.

D Brush strokes of thick gouache 'dry brushed' over a dry wash with a stiff brush to give a broken effect.

E Diluted gouache, dry-brush
gouache and slightly moistened
gouache painted over a dark
ground.

F Fruit drawn with a brush and
gouache on tinted paper.

G Another gouache drawing of
fruit, with thick white gouache
on the cut face of the apple.

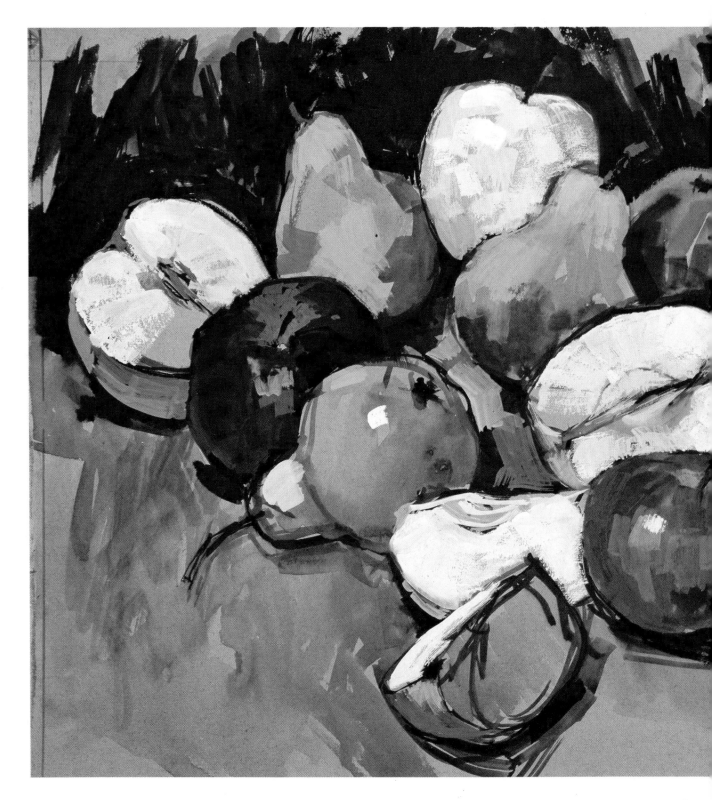

Gouache: *Pears and Cut Apples*

Some of the effects shown on the previous page were employed in this painting of fruit.

I saw the cut apples first as strong light shapes, almost cut out, against a dark background. The curves of the fruit were mostly made up of straight angular lines to give character and decisiveness. The cut faces of the apples tapered – and reminded me of the shape of butterfly wings.

The apples and pears were painted on a mid-tone grey mount board and the outlines drawn in with a no. 4 sable brush and diluted blue gouache – later strengthened in places with a darker and less diluted gouache. The apple on the right shows how I altered the drawing

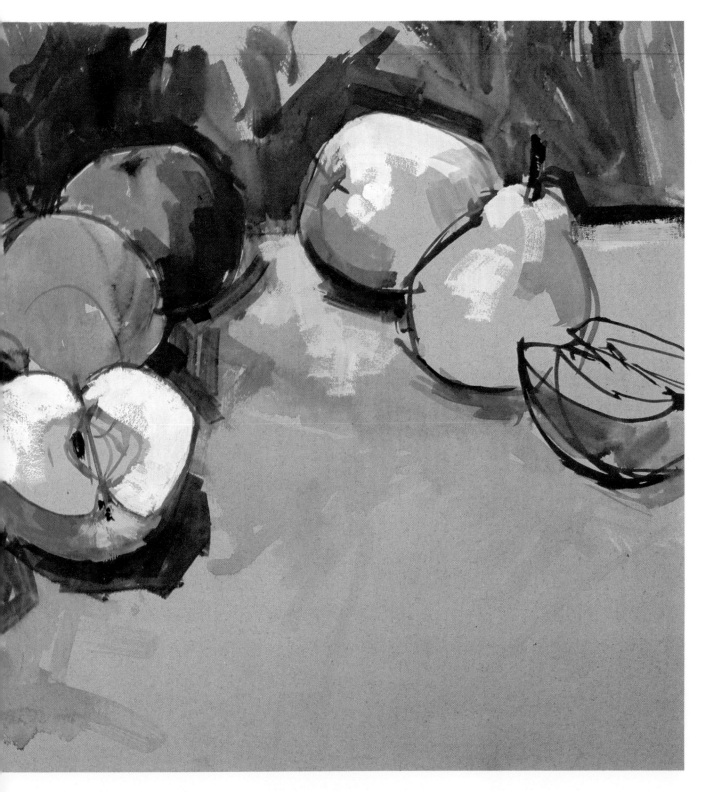

quite freely at this stage, leaving the first lines still showing. These were, of course, later covered over with thick paint – it does not really matter how many alterations are made in the early stages!

Next I worked on the background with a $\frac{3}{4}''$ flat sable brush, bringing the dark vertical brush strokes down to the edges of the fruit. Then I considered the mid-tones and applied various mixtures of olive green, raw sienna, raw umber and blue. More darks were added in the shadow areas between the fruit and dark details such as apple pips and stalks were touched in with a small sable brush.

The light areas were painted last, with very thick gouache, dragged in places so that the board just showed through. The thick paint intensified the feeling of light on the cut faces of the apples.

Watercolour techniques

A

B

C

D

Unlike gouache, transparent watercolour allows the white paper to reflect light through the washes of clear colour. It is therefore important to keep the colours clean and clear – so several pots of clean water should be at hand. Have plenty of paint mixed in the palette before work starts. Watercolour is much lighter in tone when it dries than when it is wet on the brush. Allow for this by mixing the paint in a stronger shade than you want.

These diagrams show how to achieve different effects with watercolour:

A Pigment mixed with plenty of water.

B Less water and more pigment.

C Very little water and plenty of pigment.

In each case, where the areas of colour overlap the strength of tone is greater.

D A light wash of red painted on dry paper so that it dries with a hard edge, then a blue wash superimposed which also dries with a hard edge.

A hard edge to a wash is obtained when the paper is dry. To tell whether the paper is dry, look horizontally across the surface: if the paper has a shine, then it is still wet and should be left a while longer.

Where the blue overlaps the red a third colour, purple, is produced. Similarly, of course, if yellow overlaps blue, green is produced. Because of the transparency of watercolour many colour variations can be produced from a very limited palette in this way. But do not try to superimpose too many colours as the white paper will then be unable to reflect the light and the effect will be dull and muddy.

E One colour wash laid next to another before the first is completely dry so that the adjoining edges are very soft.

A wash on damp paper always produces a soft edge. If the paper dries too quickly and there is an unwanted hard edge, this can be softened with clean water on a small brush and then blotted dry with a tissue.

F An area of wet-into-wet painting. The paper is brushed with clean water on a large brush and colour is applied immediately. The colours spread out and float into each other, the effects varying according to the amount of pigment and the amount of water used.

Generally speaking, watercolour painting does require a lot of patience and self-discipline. Paper has to be at the right degree of dampness or dryness for the kind of edge value required – very hard or very soft or at any of the different degrees of hardness and softness that come between.

E

F

DEMONSTRATION IN WATERCOLOUR:
Flowers in a White Pot

My first demonstration of transparent watercolour is a spontaneous painting which shows a direct technique with very little drawing and many of the edge values described opposite.

I saw these flowers in a little white pot as a bright patch of colour in a patchwork of olive greens and blue greys. The leaves almost disappeared as their colour merged into the background colours, but the flowers themselves stood out from this dark background with glints of light and sparkle. I felt that the overall effect could best be captured in watercolour, with combinations of wet-into-wet and sharp-edged colour washes.

Materials

Brushes: $\frac{1}{2}''$ sable (chisel end), squirrel no. 12 (round), sable no. 6 (round), piece of stick.

Paper: Saunders, NOT watercolour paper (140 lbs: 285 g/m²).

Watercolours: vermilion, Payne's grey, permanent rose, burnt umber, olive green, raw sienna.

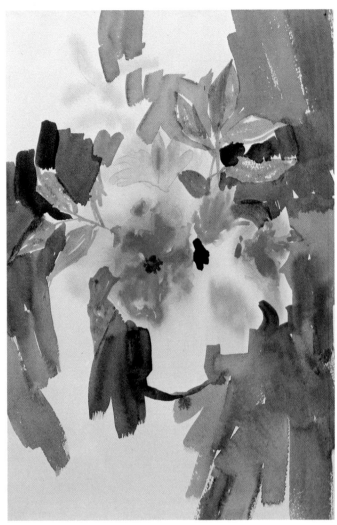

STAGE 1

I outline faintly a few leaves and the solid shape of the vase with a pencil. I deliberately do not draw in the flowers because they will be better drawn with a brush. I dampen the paper with clean water and brush in the flowers with vermilion and permanent rose.

STAGE 2

When the paper is dry, I brush on strokes of moderately diluted Payne's grey, burnt umber and raw sienna to form the background. Because the paper is dry these brush strokes are hard-edged so that the background effectively defines the shape of the vase and some of the flowers and leaves. I then paint in some of the flowers and leaves with the round sable brush.

STAGE 3

I paint the rest of the white shapes to complete the flowers, leaves and vase. Within each shape I allow the colours to touch each other so that they blend softly together as a contrast to the hard edges in the painting. I leave a few spots of white paper showing to suggest the glints of light that I first noticed in the group. Here and there I add a bit of sharp drawing with a stick and watercolour.

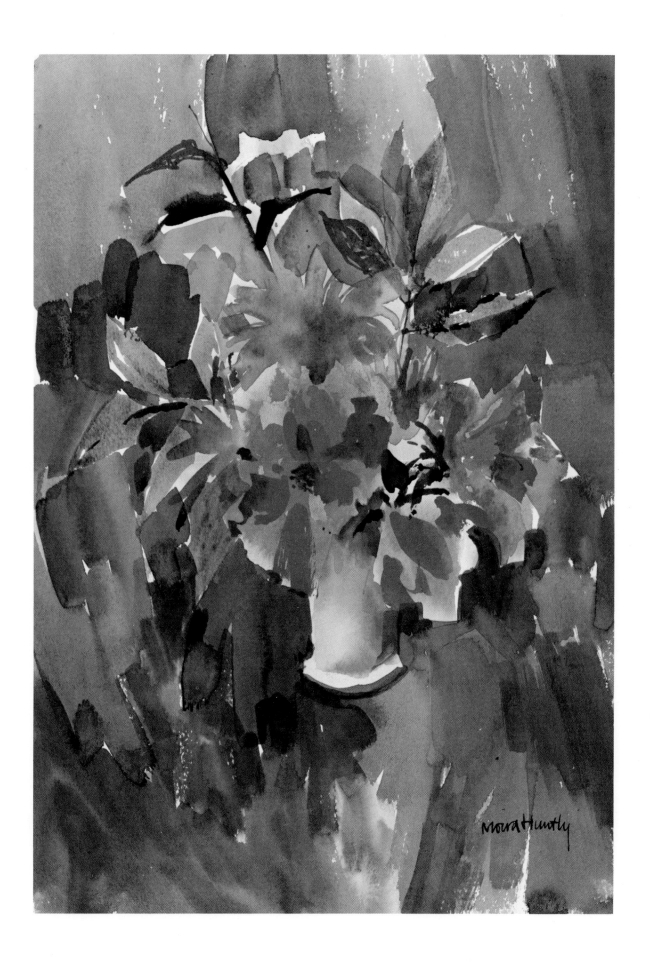

Hints about flower painting

A B

Do not be afraid to use bright colour. Watercolour pigment always dries lighter and is less intense than when applied so it is not easy to give flowers the brilliant colours of nature. Small areas of unpainted white paper left showing through can give sparkle and life, while a neutral background will help to make flowers look fresh. In this painting I started by painting the flowers on white paper – but sometimes I find it easier to judge the tonal value of the flowers if I have painted the background first.

The flowers opposite took only a few minutes to paint and are a spontaneous interpretation of the pattern and interplay of lights and darks. My treatment of the flowers was simple and I kept their shadows soft and clean. Sometimes a leaf is dark against a pale background and at others (as on the left) light against a darker area. Simple pots are best so that they do not distract the eye too much from the main subject, the flowers.

This pot has a hard-edged shape on the left-hand side and along the base, but its right-hand side fades into the background. The shadow on the pot under the petals has a soft edge as it emerges into the light and a small, sharp accent of hard edge against a petal at the top of the pot, which brings the right-hand petal forward.

Some of the leaves and the stem were made more detailed by drawing with a stick dipped in watercolour. As a line was drawn it flared where the paper was still damp.

The two diagrams above show the effects of brush and stick drawing with watercolour on a damp background (A) and on a background which is completely dry (B). Pen dipped into watercolour and drawn on a damp watercolour wash is also pleasing.

DEMONSTRATION IN WATERCOLOUR:
Still Life with Oranges

Materials

Brushes: 2 round sable no. 10, $\frac{1}{2}''$ sable (chisel shaped), piece of stick.

Paper: Bockingford watercolour paper (140 lbs: 285 g/m²).

Watercolours: cadmium red, cadmium orange, burnt sienna, ultramarine blue, cyanine blue, sepia.

Small sponge.

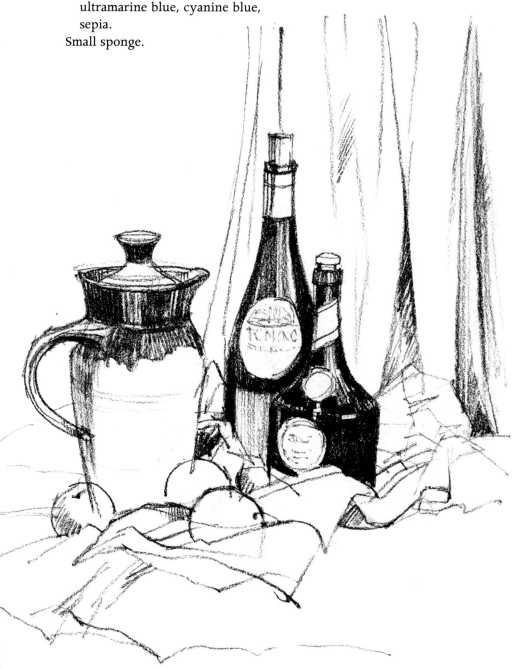

STAGE 1

First of all I mix plenty of cadmium red and cadmium orange in separate compartments of my palette and have two large no. 10 brushes ready. Then I dip a small sponge into some clean water, squeeze it out and dampen the paper. I start the painting with wet-into-wet washes freely applied without any preliminary drawing. I brush on some cadmium red with one of the brushes and then some cadmium orange with the other.

Having two brushes ready and the paint prepared speeds up the process of applying paint wet-into-wet and does not allow the edges to dry too soon.

(STAGE 2 on page 126.)

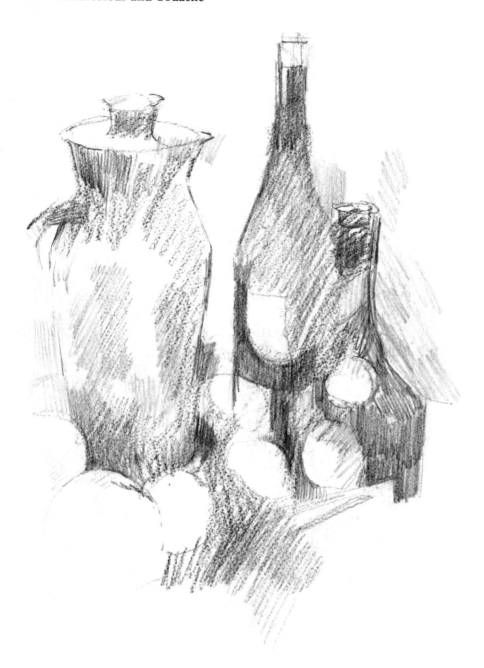

I made this quick diagram to illustrate some of the things that were of importance to me in this still life group. I saw the subject in terms of brilliant light on the oranges, which is echoed on the circular label on the bottle. Light passages occur in the background also and they show off the softly cast shadows of the bottles. The bottles and the jug are made up of various intensities of dark against the brilliant light. The diagram picks out the important passages of light and dark and shows how the labels echo the rounded shapes of the oranges.

I was also interested in the spatial arrangement of the objects, the way in which the two bottles overlap and the gap between the bottle and the jug which gives a feeling of space and distance beyond.

It becomes natural for the eye to look for such relationships between objects and at shapes that are echoed. Such considerations form an important part of the construction of a successful still life arrangement and will stimulate interest in the painting even though the viewer may be unaware of the reason. Such factors are equally important in landscape painting where the relationships are between, say, clumps of trees, buildings and machinery, and the shapes of fields, hills and buildings may echo each other.

As well as doing the more finished type of drawing shown on page 122 at the beginning of this demonstration, I like to make several quick free sketches in direct charcoal strokes as shown here, in order to explore the basic structure of a subject. I do them for my own enjoyment and not necessarily as a preliminary to painting, but they are certainly useful when I come to create a more formal composition.

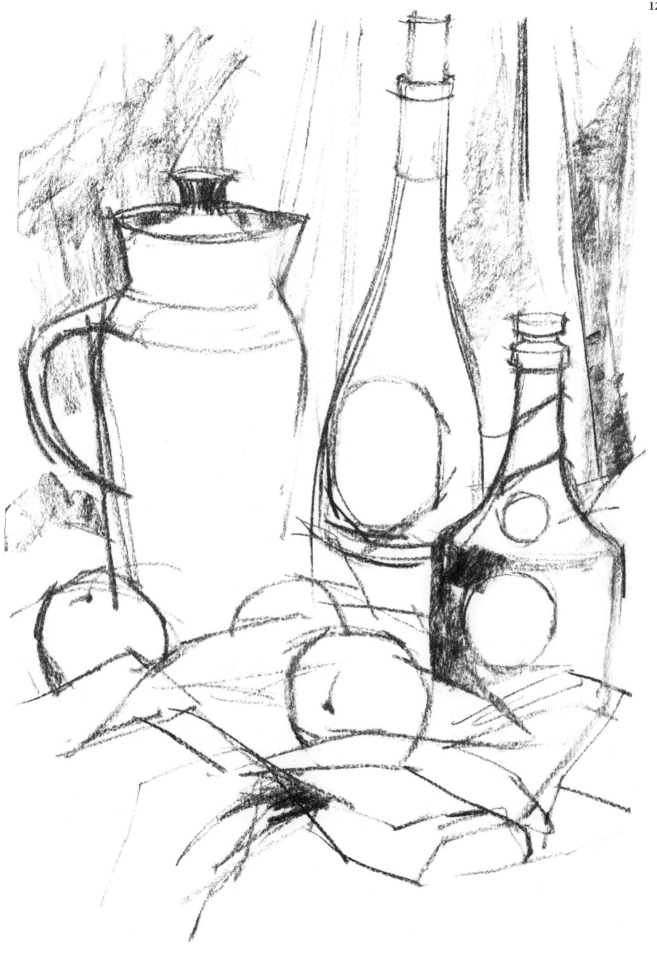

STAGE 2
(STAGE 1 on page 123.)
Working quite quickly I add some areas of burnt sienna and then I use the chisel-ended brush to paint in the darks. These are a mixture of cadmium red and ultramarine blue.

STAGE 3 (Final)
Then I start drawing in the objects with a piece of stick dipped into sepia watercolour. As some areas of the painting are still damp, the line flares into the background in places. I like some of the unexpected effects that this gives. Larger areas of dark are painted with the $\frac{1}{2}$'' chisel-ended brush and a mixture of sepia and cyanine blue watercolour.

My aim in applying these darks is to bring out the richness of colour of the first washes and to create a pattern of light on the fruit and on the labels of the bottles.

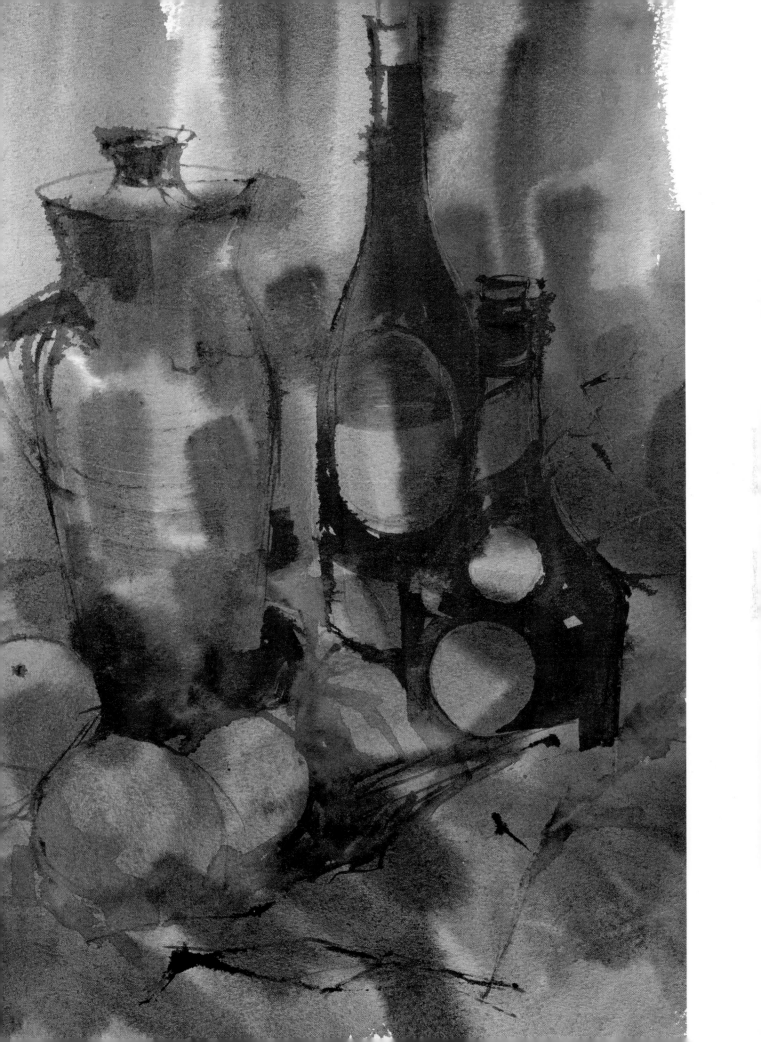

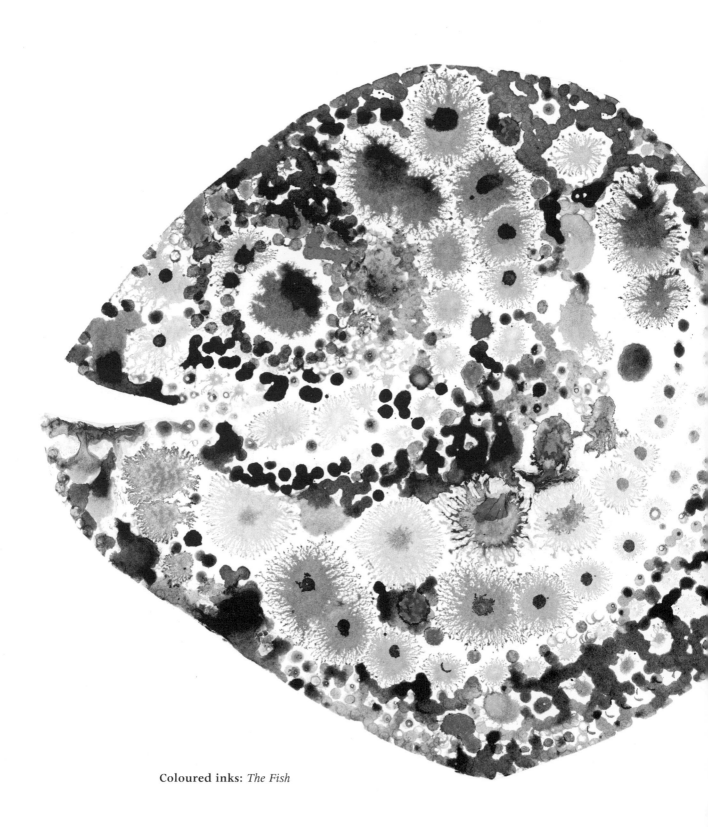

Coloured inks: *The Fish*

CHAPTER EIGHT

Imaginative Painting

So far in this book I have looked at still life from a mainly representational viewpoint but it can also form the basis of more imaginative and abstract painting and of abstract designs. The shape, volume and structure of objects are necessary elements in a representational painting but they can also be appreciated in an abstract sense and the forms modified by the artist into flat decorative areas or a series of planes.

It is very interesting to make a detailed drawing and then to analyse the drawing into its fundamental pattern. The elements of a pattern to look for are the underlying shapes, curves, thickness of line, the way one curve repeats another, and how one part is dark against the light and *vice versa*. The balance of the composition may require some rearrangement of the parts – and

composition is a subject which is discussed in this chapter.

The source of subject material for this kind of design work is endless: stones and shells on a beach, plants, vegetables, seaweed, a slice of cucumber, the triangular overlapping pattern of fish scales, the rough bark of a tree – all suggest interesting possibilities for designs, patterns or imaginative and abstract paintings.

The fish shown here was an ink blot design which I did for fun with my children. We cut fish shapes out of white paper, wet them with water and dropped coloured inks on to them. The small circle marks were made with the end of a straw. In the example here I used viridian, olive green, magenta and blue to produce a brilliantly coloured decorative effect.

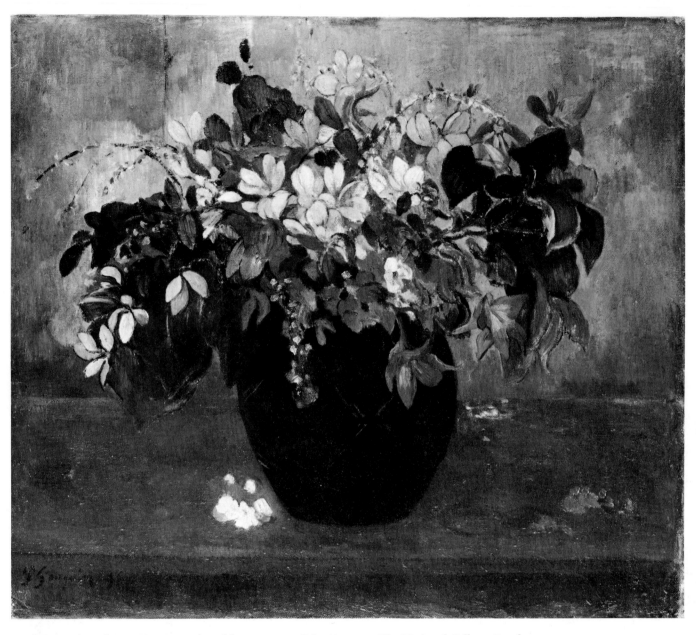

Paul Gauguin: *Flower Piece* Reproduced by courtesy of the Trustees, The National Gallery, London

Composition

I have discussed composition in general terms throughout the book as it is such an important part of any form of painting whatever the medium, but its role is particularly important in abstract painting. Many abstract paintings explore the two-dimensional vision of pattern, colour, tone and texture; it is a well-developed sense of composition and colour which will give coherence and force to paintings of this kind.

Sometimes good composition can be achieved without effort — some people have an inborn sense of the balance of visual areas. In my opinion, composition is essentially the division of a surface to give the most visual satisfaction.

The painting entitled *Flower Piece* by Gauguin is a very simple and appealing composition. The background and pot are subtle in treatment so that the flowers become the important part of the painting. The arrangement of the flowers is

balanced nicely, but too much symmetry has been carefully avoided: the leaves on the right are higher than those on the left and the shape of the vase is broken by overhanging leaves and flowers. The large dark area of the pot is balanced by the small touch of light on the fallen petals. If this light is covered up, the painting lacks sparkle without it.

Gauguin's painting is not of course an abstract painting; we recognise the subject matter, but it is the

underlying abstract qualities which it possesses that make it a great painting.

There is an element of design in all paintings whether they are purely representational or whether they are symbolic, more abstract paintings such as Mondrian's *Ginger Pot II*. Mondrian was a twentieth-century Dutch painter who interpreted Cubism in an individual way. In later years his work became totally non-representational but *Ginger Pot II* is one of his early still life paintings, dated 1911–12.

It is a very linear composition, already showing signs of Mondrian's later exploration of the right-angle. The ginger pot dominates the painting and its shape is repeated and echoed several times. The light areas of the painting seem to glow out of the surrounding darker tones.

There is nothing new about abstract art. From ancient times the view has been held that artistic value lies in form and colour, independently of subject matter, and this gives the artist great freedom of expression. This freedom does not mean an

abandonment of discipline: it is still necessary – perhaps even more necessary than in representational painting where the subject may be attractive in itself – to achieve a balance in the composition between emotion and formal arrangement.

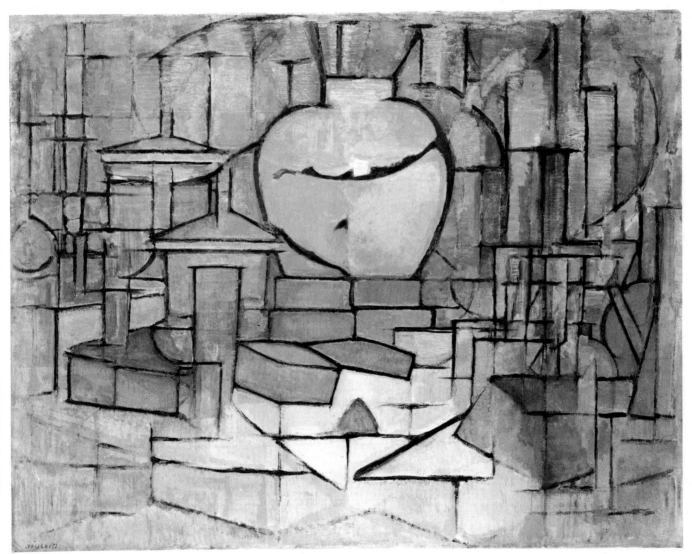

Piet Mondrian: *Still Life with Ginger Pot II* Reproduced by courtesy of Collection Haags Gemeentemuseum – The Hague

André Derain: *Still Life* Reproduced by courtesy of The Hamlyn Group Picture Library

Illustrated above is Derain's still life painted in 1904. An ambitious and dynamic composition, it too has light areas that seem to glow out of the darks in the painting. It is a large design and the clever distribution of lights and darks form quite an abstract pattern. The strong light and the movement in the cloth act as a nice foil to the more muted tones of the static objects in the background. The stability of the whole is maintained by the very strong pyramidal shape of the cloth, with the bottom edge of the painting as the base-line of the pyramid.

The painting is visually exciting and I find its composition particularly satisfying.

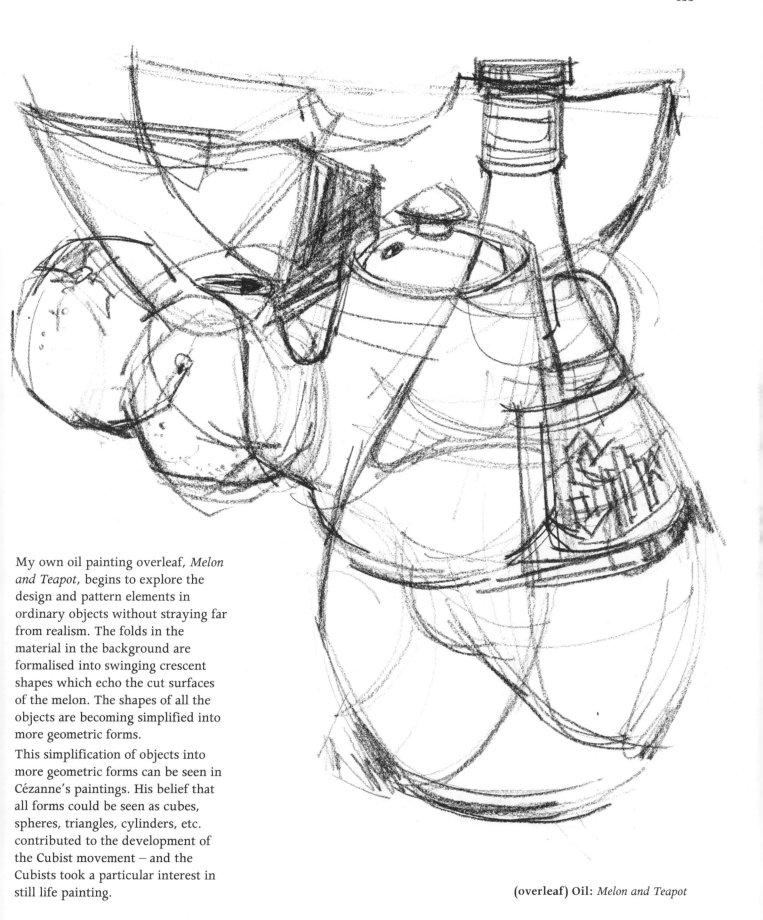

My own oil painting overleaf, *Melon and Teapot*, begins to explore the design and pattern elements in ordinary objects without straying far from realism. The folds in the material in the background are formalised into swinging crescent shapes which echo the cut surfaces of the melon. The shapes of all the objects are becoming simplified into more geometric forms.

This simplification of objects into more geometric forms can be seen in Cézanne's paintings. His belief that all forms could be seen as cubes, spheres, triangles, cylinders, etc. contributed to the development of the Cubist movement – and the Cubists took a particular interest in still life painting.

(overleaf) Oil: *Melon and Teapot*

Design and pattern

Design-making requires the same awareness of spatial relationships, of tone and pattern, and the same feeling for composition as painting does. Natural objects have much to offer the designer who can get to know them initially by making a sketch and observing the colour.

I like to take my sketchbook out into the countryside where I make fairly detailed studies. Later in the studio I distil the sketches into their essential forms and these I use as motifs for designs. This close examination of natural objects is often most rewarding; the details observed can provide inspiration for both design motifs and for more abstract painting.

The pine cone shown here could have formed the starting point for a straightforward still life painting; viewed from the end it became a simplified pattern with many design applications, e.g. fabric, pottery, wallpaper, tiles or wood carving.

Sometimes I take specimens home where I can more conveniently analyse them in terms of colour. If, for example, I observe that a plant leaf is composed of three shades of green and a small amount of red, I may decide in my mind the proportions of each green in the leaf and the exact amount of red, and then repeat these proportions of colour in a more abstract way in a design.

Design: *Candles and Berries*

Here I made a design drawing from a candle and leaves on a table as Christmas decorations. The whole drawing was initially of thin lines from a fine fibre tip pen, with some of the lines and shapes overlapping. Then some of the lines were thickened to emphasise a stronger design pattern.

I decided halfway through that I liked the combination of thick line on one side and thin on the other – and left it at that.

The final design was of thick lines only so that I could use it for a lino-cut which was printed as a Christmas card.

The invitation card design (also printed from a lino-cut) was based on common still life objects – glasses, mats and straws – their shapes simplified into a two-dimensional pattern.

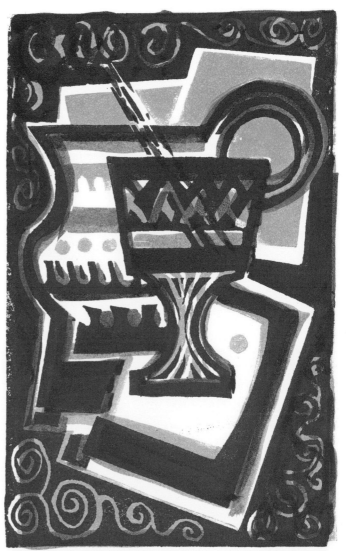

Linoprint: *Invitation Card*

Linoprint: *Christmas Card*

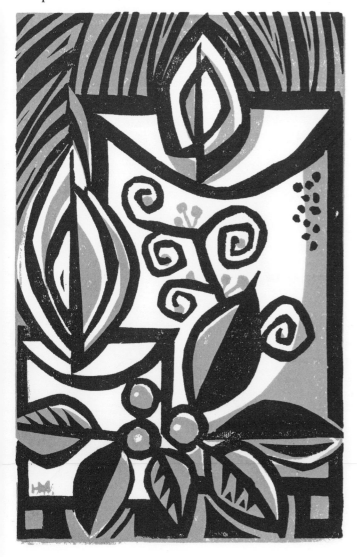

Monoprint in watercolour

Simple shapes, or a more complicated design, are painted in watercolour on a sheet of glass or a piece of plastic sheet. Before the paint dries, a sheet of paper is placed carefully on the sheet of glass. With gentle pressure on the back of the paper the image can be transferred from the glass to the paper. The image is reversed left to right and this reversal is interesting in itself as it gives new understanding of the composition and can lead to further development of the painting.

William Blake pioneered this method of making an offset print or monoprint. He used such prints as a background on which to paint, but they can be left as complete statements in themselves.

A I paint the bottles on a sheet of glass with sepia watercolour and then wipe away some of the paint with a rag to make clear passages and outlines which will show as white in the printed image.

B I press a piece of paper on to the glass to produce a reverse image. The pressure of the paper on the glass breaks up the paint into globules and this shows on the finished print.

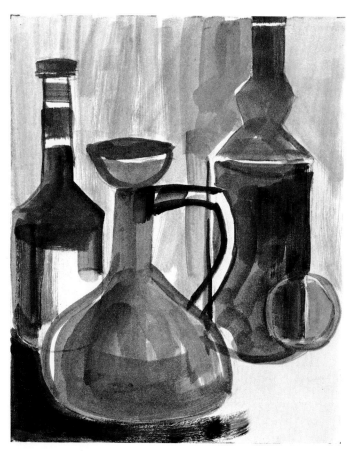

A

B

The objects on which I based this monoprint are the same as in the still life painting in oils that appears in colour on page 44, *The Blue Bottle*, and here in black and white. This time, however, the bottles are used purely as a starting point for an exploration of the more abstract qualities afforded by this method.

The print quality of the method is particularly evident in the dots and blobs of the first image (**B**).

The Blue Bottle
(page 44)

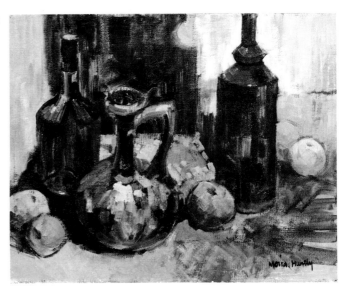

C This monoprint is in two colours. I mix washing-up liquid with the paint to keep it moist while I paint the colours on to the glass. I paint a slightly different arrangement of bottles on the glass, with brown for the background and blue for the bottles, and I wipe away some of the paint to give a different pattern of white. This time the paint transfers without separating into globules and I think this is because the washing-up liquid holds the paint together.

D This monoprint looks different again because the paint image is printed from the glass on to damp paper. On this print I add a little gouache to bring up the highlight on the bottle.

C

D

DEMONSTRATION OF STENCILS WITH
Bottles and Fruit

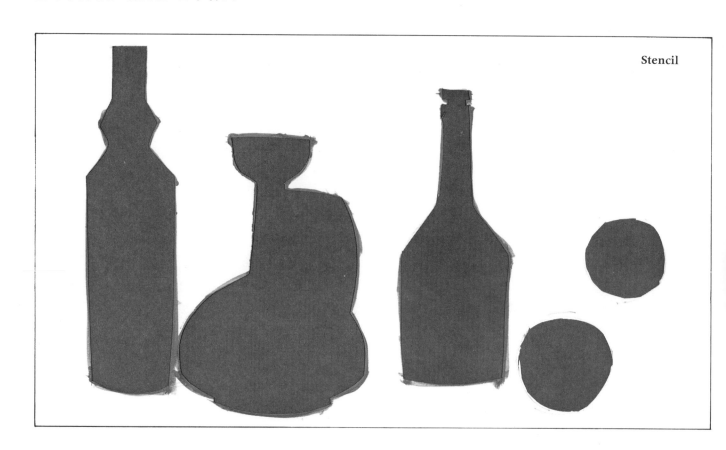

Stencil

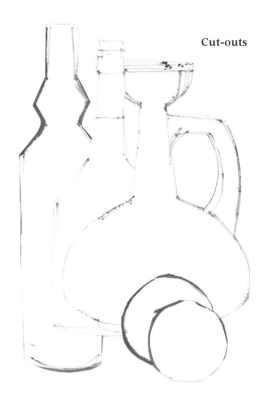

Cut-outs

Materials

Brushes: 1½'' flat wash brush, ½''
 chisel-ended sable, no. 5 round
 sable.
Paper: scrap piece of card, Arches
 watercolour paper (90 lbs: 180
 g/m²).
Watercolours: raw sienna, brown
 madder, ultramarine blue, burnt
 sienna.
Gouache: Winsor green, olive green,
 lemon yellow, permanent white,
 cadmium orange, burnt sienna,
 black.
Safety razor blade.

WATERCOLOUR AND GOUACHE:

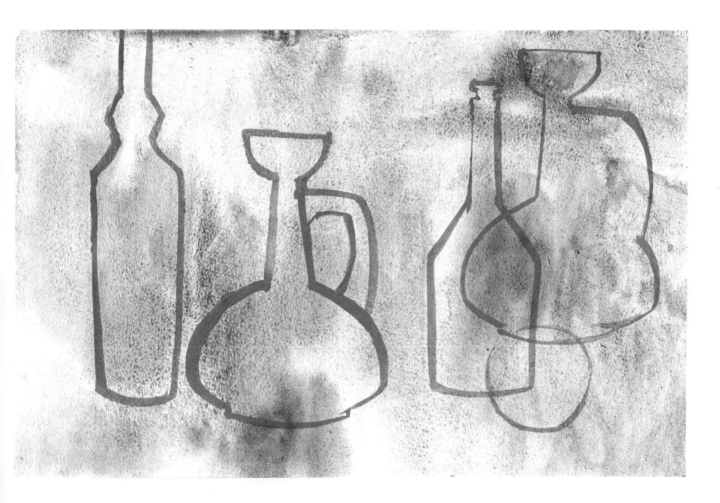

By now this particular group of objects is becoming very familiar! The bottles and apples in my painting of *The Blue Bottle* (page 44) gave me inspiration for yet another interpretation. This time I am concerned primarily with the simplified flat shapes of the bottles and fruit and the pattern that emerges when these shapes are repeated and overlapped.

The demonstration is of stencils used to build up a satisfactory composition. With a felt tip pen on a piece of old card, I draw the bottles, in outline only, and then two circles of different sizes to represent the apples. Then I cut out the shapes carefully with a razor blade so that I can use either the cut-out shapes themselves as templates or the now perforated piece of card as a stencil. Both are useful: the templates to mask areas or to be moved about until the arrangement seems right; the stencils as holes to paint round or through. The use of templates is a good way of arriving at a good composition before committing brush to paper or canvas.

STAGE 1

Working wet-into-wet with the large wash brush on a stretched piece of watercolour paper, I brush on loose washes of the four watercolours. When these are dry I draw round inside the stencil shapes with the no. 5 round sable brush and Winsor green gouache.

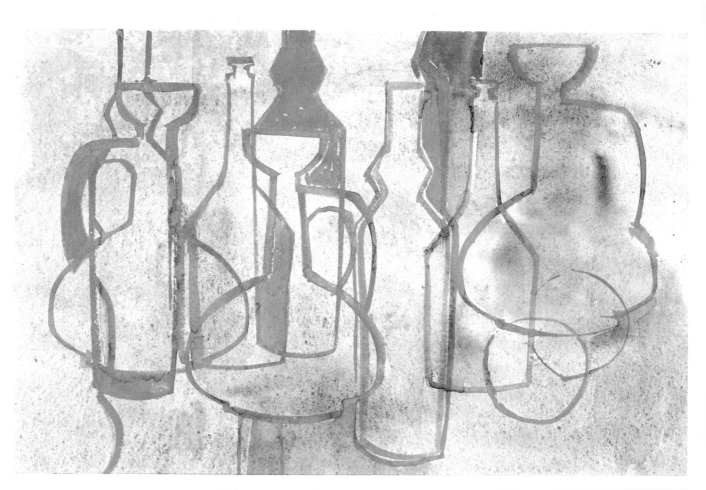

STAGE 2

I repeat and overlap some of these outlines by moving the stencil about. Then I fill in some of the shapes with more Winsor green gouache.

STAGE 3

I continue to build up a pattern, this time adding black gouache to fill the spaces between the bottles and thus creating negative shapes that become part of the design. I spatter drops of watercolour over parts of the painting.

STAGE 4

I continue to build up the dark pattern, introducing some areas of olive green and burnt sienna, and then I apply light-coloured gouache to the painting – mixtures of lemon yellow, orange, or burnt sienna added to white in varying proportions. The paint is applied with a dry brush (the $\frac{1}{2}''$ square sable) to give a broken effect with the underpaint showing through.

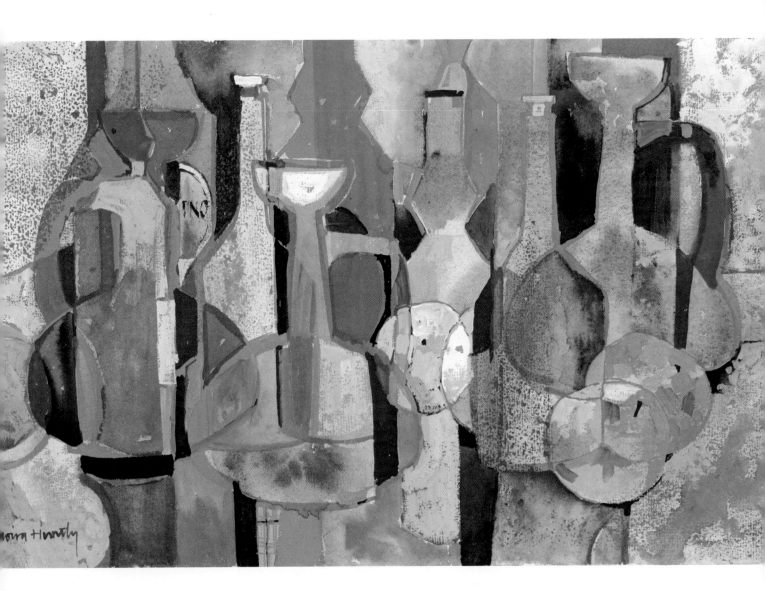

Acrylics

Acrylics: *Driftwood*

Acrylic paint is pigment bound with a synthetic resin. Acrylics are highly versatile for they can be used thinly as transparent washes or thickly like oil paint, they are permanent and they dry quickly. They can be used on almost any dry surface except a greasy one, without any preliminary sizing or other preparation. If a primer is thought necessary, it should be an acrylic primer so that there is no reaction between the chemicals in the primer and those in the acrylic paint. Acrylics can be diluted with water but when they are dry (the water having evaporated) they become waterproof and cannot be removed. Any kind of brush or palette knife can be used but must be rinsed thoroughly in water immediately afterwards.

I often seek inspiration for still life paintings on the beach. One day I found a piece of driftwood caught in rocks just above the high water mark. Part of it was charred black and one of the knot-holes had a dark stone wedged tightly into it by the sea – a perfect fit. I was fascinated by the abstract shape and the texture of the wood and rocks and made many drawings from different angles.

A mixture of charcoal pencil and cool grey pastel enabled me to note the changes of tonal pattern, particularly among the rocks and stones. The driftwood no longer seemed to be a 'still' life but to be full of vigour and the rough shape began to look like some prehistoric tool.

At home I used one of the drawings of driftwood as a basis for the painting in acrylics on page 147.

Materials

Brushes: 1½″ flat wash brush, round sables no. 7 and no. 4, hog hair brush no. 9.
Paper: Bockingford watercolour paper (200 lbs: 410 g/m²).
Acrylics: ultramarine blue, black, white, burnt umber, burnt sienna, raw sienna.
Palette knife.
Tissues.

To start the painting of driftwood I covered the paper all over with the flat wash brush and blue acrylic paint in a transparent wash which dried immediately. I was then able to draw the shapes with the smaller round no. 4 brush and blue/black paint over the wash. It is easy to draw with a brush and thinned-down acrylic paint – very fine lines can be applied if required.

I built up a monochrome underpainting, using the round no. 7 brush, and painted in cool greys and blues, using mixtures of white, blue and black, with plenty of blue in the coldest parts and thinned blue/black for the darks.

Then I built up the painting with thicker light paint on top of the monochrome underpaint, sometimes using the hog hair brush and sometimes a palette knife. The light paint consisted of mixtures of white with a small amount of black, of white with burnt umber, and of white with a small amount of black and burnt sienna. At this point the painting was very cool, almost clinical, and I warmed it by flooding the surface with much diluted washes of burnt sienna and raw sienna. Before the washes dried, I blotted off some areas to recover the background.

Acrylic paint is ideal for such a layering technique. This painting received a series of layers: thin wash, thin underpaint, heavily applied thick paint and thin wash again for the final stage. There is considerable versatility as thin paint can be applied over thick, or thick over thin, without any fear that it will not adhere or that it will crack with age.

Moira Huntly

(above) Charcoal, pencil and pastel
(opposite) Acrylic: *Driftwood*

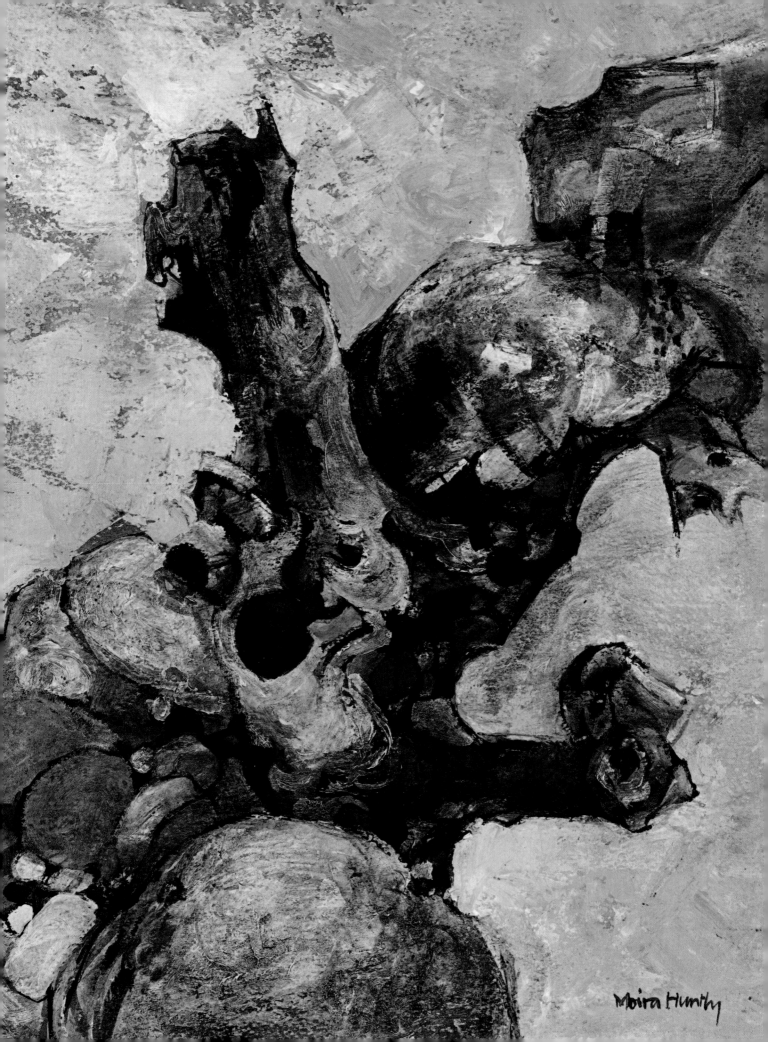

Rhythms

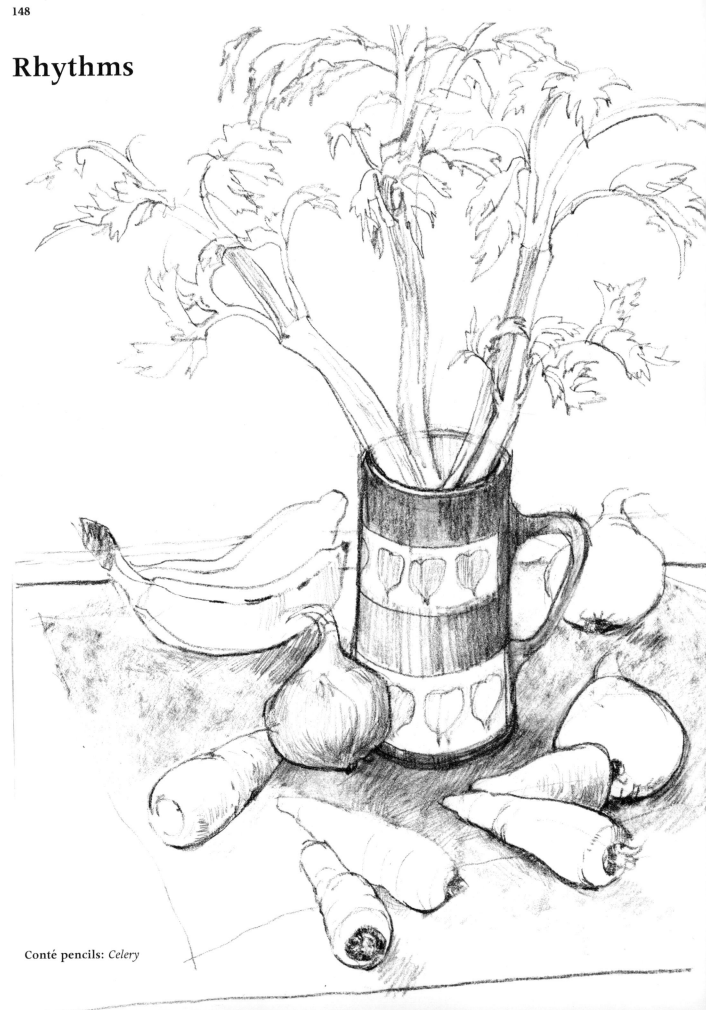

Conté pencils: *Celery*

Natural forms possess interesting rhythms and movement. A study of natural forms with this aspect of them in mind often produces paintings with a different emphasis from the usual one of literal interpretation.

I saw some vegetables grouped haphazardly on the kitchen table and was struck by the movement and rhythm in the group. I thought this would make a good subject for an abstract painting of rhythm, and not merely repetitive rhythm.

As it is always a valuable exercise to get to know the subject through a preliminary sketch, I first made the literal study (shown opposite) with Conté pencils. The act of doing so made me study the curves and rhythms more closely and helped me when I came to translate the subject into a more abstract pattern. In the final painting (see page 151) I emphasised the curves of the celery leaves, the onions and the brown pot so that they appear to twist and turn; this creates a sort of movement within the group. I extended the painting to include a bowl and bananas which repeat the curves of the celery leaves.

The five diagrams show the process of my thinking and the selection and simplification of, for example, the leaves into more abstract shapes.

In diagrams 1 and 2, the complicated leaves of the celery are simplified into one large silhouetted shape.

Diagrams 3, 4 and 5: the jug in the sketch shows dark shapes on a white band. In my painting I see these dark shapes as echoes of the onions and the white spaces between the shapes also echo the onions instead of being a simple white band. So in the painting there is a counterchange pattern of light and dark onion shapes.

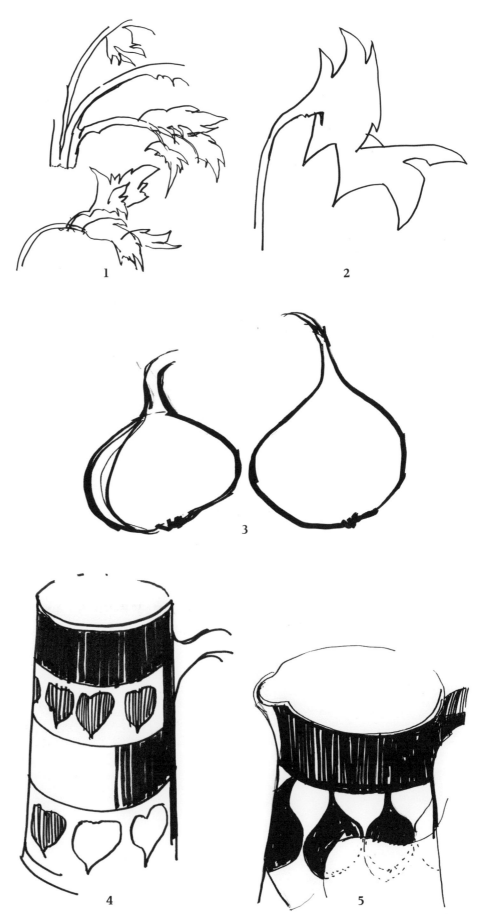

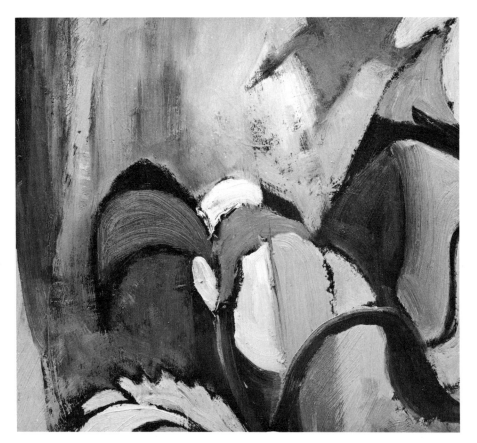

In the black and white reproduction of a detail from the colour painting opposite, the vigorous brush work is more apparent. Most of the edges are soft, the dragged paint allowing some of the background to break through here and there. The brush marks follow some of the movement in the subject.

The final oil painting (on hardboard) looks colourful but my palette was in fact quite limited. I used the same yellow for the celery leaves and the onions, and the same brown for the pot and the carrots and on some of the leaves. A limited palette gives a painting unity and I unified it further by echoing the colours of the objects in areas of the background.

The paint was applied in vigorous curving brush strokes on the vegetables and fruit and on the background, so that everything contributed to the feeling of movement.

(above) Full-size detail from
(opposite) Oil: *Rhythms*

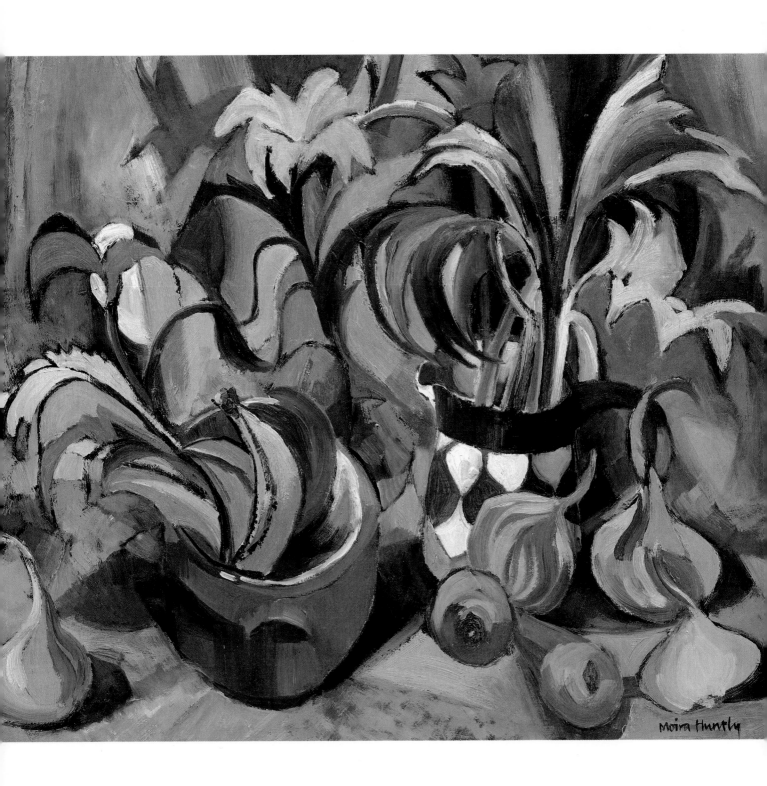

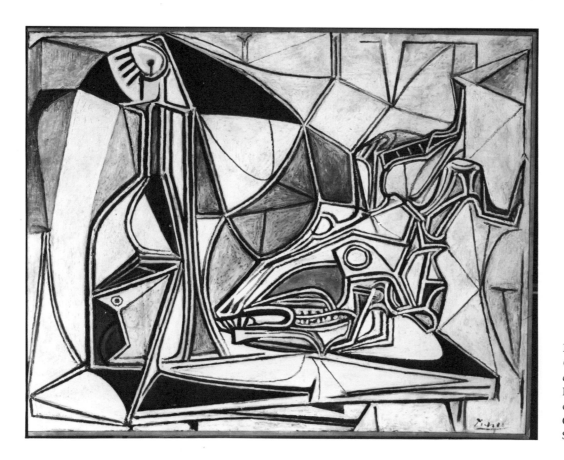

Pablo Picasso:
Goat's Skull, Bottle and Candle
Reproduced by courtesy of The Tate Gallery, London ©
SPADEM Paris 1982

Graham Sutherland: *Green Tree Form: Interior of Woods* Reproduced by courtesy of The Tate Gallery, London

Contemporary abstract painting

The purely visual distribution of form and colour is the common factor that links representational and abstract painting and is what the artist seeks to master. Instinctively or intellectually an effort has to be made to achieve satisfactory visual balance in a composition whatever the subject and, at the same time, however great the difficulty, to achieve a balance between emotion and formal arrangement.

The twentieth-century paintings reproduced here are all interpretations of subjects already suggested in this book. The animal skulls that fascinated me (see the drawings on page 28) were similar to those that inspired Picasso, who made many paintings with a skull as a basis. In the painting *Skull of a Goat, Bottle and Candle* which was painted in 1952, the whole of the painting is treated as a linear pattern with very little colour – it is almost monochromatic. The angular shapes are repeated on the bottle and elsewhere, and the distribution of lights and darks give movement and excitement.

Graham Sutherland's *Green Tree Form: Interior of Woods*, painted in 1940, is full of romanticism and yet there is something almost menacing about the gnarled end of the tree form. For me, this painting captures the mood and atmosphere of such a tree form in a wood. It is instantly recognisable as a natural form and yet it is also abstract and full of mystery. Sutherland sees it with his personal vision and helps us, if we study the painting, to open our eyes to such forms the next time we are walking in a wood.

Ben Nicholson, one of the most important British abstract painters, used everyday objects for his still life paintings: plates and knives, cups, jugs and bottles on a kitchen table – but he treated them as elements in his abstract paintings. All extraneous matter was eliminated in his search for pure form and he achieved a clarity and precision which are most satisfying.

Ben Nicholson: *Still Life* Reproduced by courtesy of The Tate Gallery, London

Watercolour, wax
and pastel: *Eggs*

Conclusion

Still life painting offers wide scope for personal interpretation and experiment. As still life subjects are by their nature static and most commonly small-scale and close to the artist, there is time to study them in depth, to sketch and to analyse before making a personal statement in the finished drawing or painting.

There are many different media – and combinations of them – available to the still life painter who is keen to experiment. Some of the techniques can be quite intriguing, such as the method of painting with ink over soluble paint where it is exciting to see the image emerge under the tap (see page 102). Many methods are described in this book, sometimes in step-by-step demonstrations which show the particular way in which I have tackled a variety of subjects and techniques. But these methods are by no means the only ones, and my purpose in showing them is to stimulate an interest in still life painting from which the reader may develop an individual approach.

We are always looking for different ways to paint what we feel and see and the search is never over. It is always a struggle to capture in the final painting the excitement of first inspiration and to convey the excitement to others.

While writing this book I have become more and more interested in the scope of still life painting and enthusiastic about its possibilities. I have tried to feed this growing enthusiasm by painting still life subjects myself and by looking at paintings by other artists – I was surprised and pleased to discover how many of the great masters painted still life – and I hope that other painters will be encouraged to do the same.

Bibliography

John Blockley, *The Challenge of Watercolour* (A & C Black)

John Blockley, *Learn to Paint with Pastels* (Collins)

Warren Brandt, *Painting with Oils* (Van Nostrand Reinhold)

Marcel Brion, *Cézanne* (Thames and Hudson)

Raymond Cogniat, *Braque* (Bonfini Press, Naefels, Switzerland)

Bernard Dunstan, *Starting to Paint Still Life* (Studio Vista)

Daniel Greene, *Pastel* (Watson Guptill)

Colin Hayes, *The Complete Guide to Painting and Drawing Techniques and Materials* (Phaidon)

Kenneth Jameson, *Starting with Abstract Painting* (Studio Vista)

Kenneth Jameson, *You Can Draw* (Studio Vista)

Leslie W. Lawley, *A Basic Course in Art* (Lund Humphries)

Peter and Linda Murray, *A Dictionary of Art and Artists* (Penguin Books)

Michael Pope, *Introducing Oil Painting* (Batsford, London)

John Raynes, *Starting to Paint with Acrylics* (Studio Vista, London; Taplinger/Pentalic, N.Y.)

John Raynes, *Starting to Paint in Oils* (Studio Vista)

Charles Reid, *Flower Painting in Watercolour* (Pitman, London; Watson Guptill Publications, N.Y.)

Adrian Ryan, *Still Life Painting Techniques* (Batsford)

Maurice de Sausmarez, *Basic Design: the Dynamics of Visual Form* (Studio Vista, London; Van Nostrand Reinhold, N.Y.)

Nicholas Wadley, *Cubism* (Hamlyn)

Index

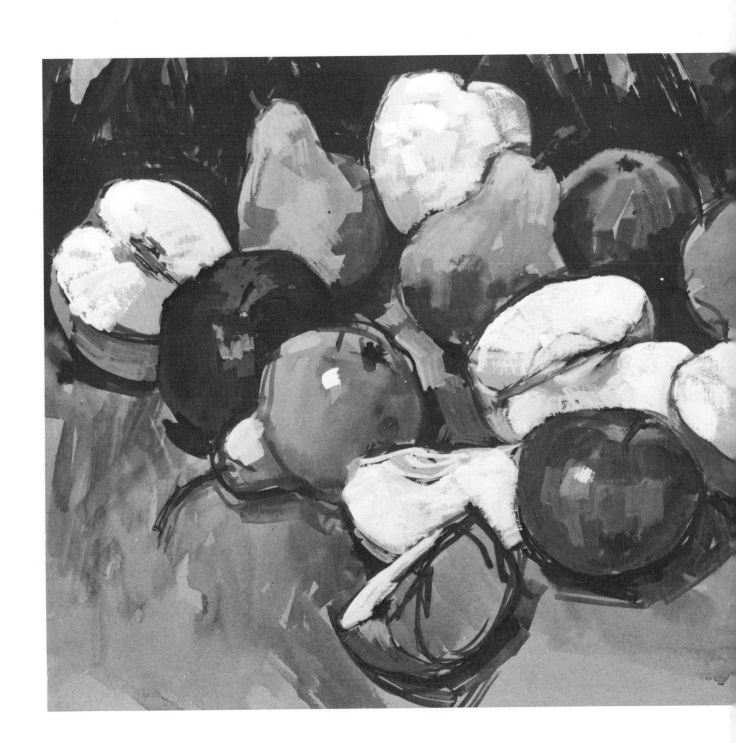

Imaginative Still Life

JE 1 '93	DATE DUE		
JY 3 '93			
AP 16 '94			
AP 5 '95			
NO 27 '95			
GAYLORD 234			PRINTED IN U. S. A.